To Jeanette from De▮▮
 Hope you enjoy this boo▮
We enjoyed getting to meet her. She pa▮▮
away in Jan. 2016.

If

There's

Squash

Bugs

in

Heaven,

I AIN'T STAYING

If There's Squash Bugs in Heaven,

I AIN'T STAYING

Learning to Make the Perfect Pie,

Sing When You Need To,

and Find the Way Home

with Farmer Evelyn

Text and Photographs
by
STACIA SPRAGG-BRAUDE

MUSEUM OF NEW MEXICO PRESS Santa Fe

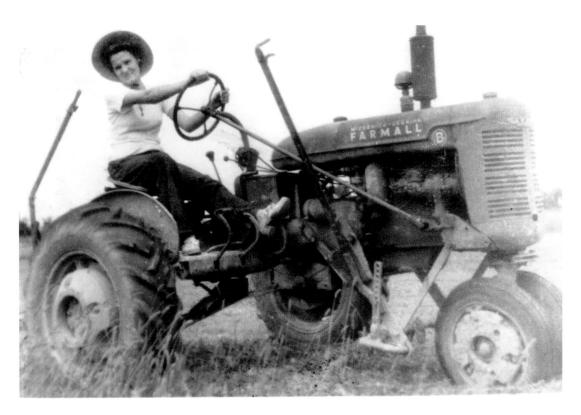

Here I am at 14 or 15 years old mow-
ing alfalfa on the Farmall.

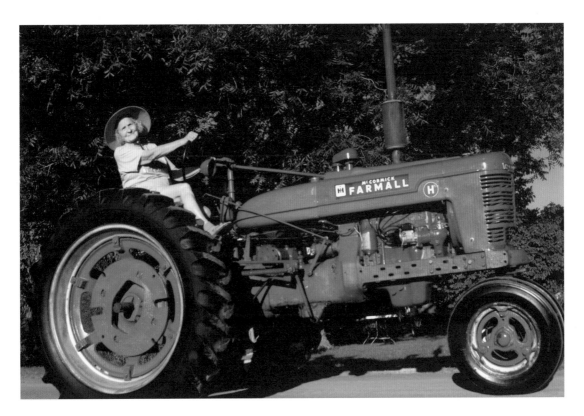

Evelyn at eighty on her Farmall, 2009

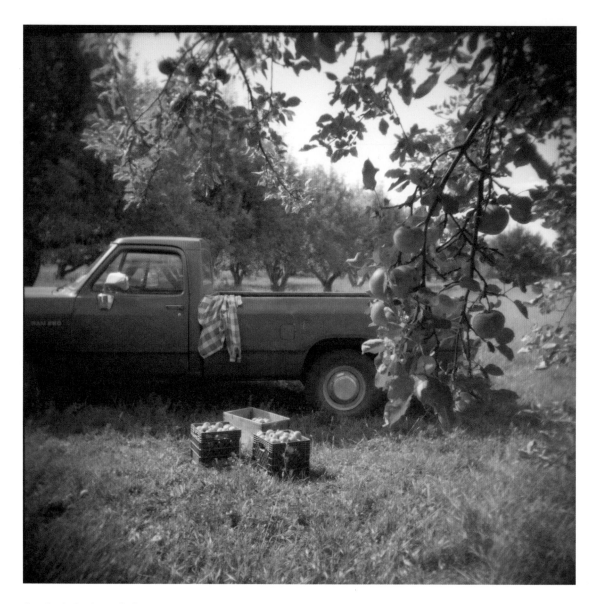

Saturday in October on the farm

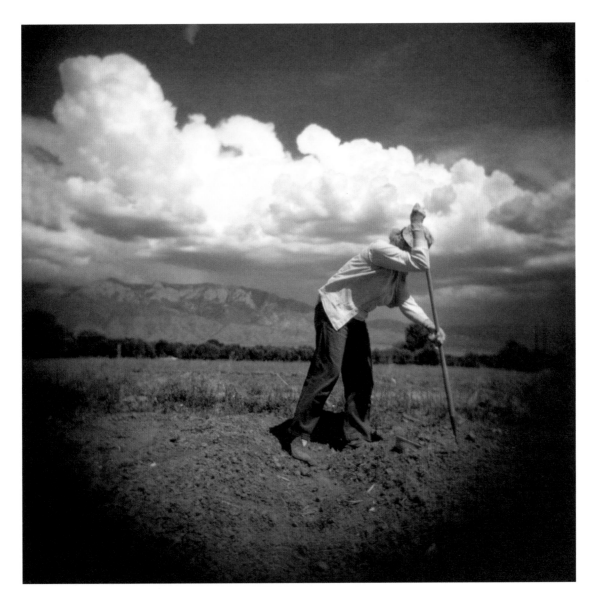

Evelyn on her land

para Corrales

Contents

I will live all my life in Corrales
Who could ask for more…

Life in the village is fiesta
Life in the village is amor
Life goes on in the village
Life goes on like a song

Days are slow in the village
Nights are never too long
Life goes on like a song

Life goes on like a song

"CANTINERAS" FROM LOS CORRALES
Michael McDaniel Montaño and Evelyn Losack

INTRODUCTION

I AM NOT FROM HERE. This was not my home. Growing up in Indiana for me was always about dreaming and studying and preparing to leave, to see the world. And for a time I did just that—traveling about as a photojournalist, in one place and then already dreaming and planning for the next. I never bothered to unpack my bags for good, just long enough for the time being. And that seemed okay. I had committed to the world. I hadn't committed to a place.

Then one day after the new year, 1996, I drove across Arkansas, through Oklahoma, through Texas, and crossed the border into New Mexico. I stopped atop a big mesa and looked down and looked west, and my heart went out across the expanse of it and it didn't come back.

I was going to do a five-month internship at the *Albuquerque Tribune* newspaper. I signed a month-to-month lease in a furnished studio apartment off a busy road in town. I saw it as a great chance to build up my portfolio, to do some hiking. The plan was to head to New York afterward, and then back overseas.

One day an assignment took me a little ways out of town to a place called Corrales—north, then west, then across the river. I turned down

a narrow, winding road that curved slowly past an old church. Past the cemetery with home-cut wooden crosses and angels and hearts, past old stands of apple trees and houses made from the earth. Past people who waved at you and you waved back. And I saw myself there.

It's been going on nearly twenty years since I crossed over to this place. The newspaper closed, I fell in love and married, we have a little boy now. I vote in regional elections. My name is on a mortgage. And people ask me, Are you staying? Is this home? And all I can answer back is: For now.

PRELUDE

THIS IS HOW THE STORY FIRST CAME to me. One night, I had a dream and in it Evelyn died. A realization haunted me awake and through the days to follow that I had never made it over to her house in the middle of the night to watch her roll out pie dough and listen as she sang opera while the pies baked and the sun came up. People would line up later in the morning at the farmers' market waiting for a dollar slice of her famous fruit pie, never knowing how it had been infused with arias in her quiet ritual before dawn, never realizing how much soul and song this old farmer has poured into this little village in the valley along the river. Never knowing that she knows the way home.

SPRING

The Curtis-Losack Farm

DREAM WHIP

*"My mother planted chile all day one day, then went home,
and I was born."*

IT ALL BEGINS WHEN THE SANDHILL CRANES LEAVE, and it ends as they come back. When they leave, you plant. When they return, you harvest.

Evelyn's day on the farm started long ago, before most were even awake. The cranes were leaving, and it was time. Despite the hour, despite it still being February and cold, I showed up early Monday morning at her farm in the village of Corrales to find Evelyn and her eighty-three years sitting on the back porch, apron over bra over another apron over jeans, slamming a section of metal pipe against a pile of pecans, sending them scattering across the table and onto the ground. Slivers of shell flew up with each thud, some into her fresh perm.

"Well now the crows can eat!" she announces.

"What are we gonna plant this year, honey? And don't leave without signing the petition to get more music into the schools."

Her voice trails off behind her, something about myopic lawmakers and lazy county extension agents, as she fires up a motorized buggy with flaming-wing stickers she's borrowed from a neighbor, a war vet with bad knees. Forward. Reverse. Now *forward*, her head jolts back as she lunges toward the Jerusalem artichokes, the orchard, the ducks of her farm, her kingdom, toward what she needs to do to get things done.

"C'mon, honey. We have work to do and pie to eat."

Evelyn Salce Curtis Losack is an old farmer, and she farms an old piece of land. Legend and archaeology show this is some of the oldest farmland in the country still being cultivated. Indians and the Spanish, French, Italians and Americans, old-timers and newcomers have all been planting along this stretch of the Rio Grande in central New Mexico for thousands of years. Evelyn is just the latest soul to work this land.

Evelyn was one of the first people I met when I first visited this place years ago. She was covered in mud.

I had heard about her and about Corrales. My mom was visiting from Indiana at the time. One day we decided to head north to the village where the annual spring cleaning involved the mudding of the local church. Corraleños built it from adobe bricks a century and a half ago in honor of Ysidro, who legend has it was out working in his crops and stopped mid-field to pray. As he did, an angel came and finished planting his rows, and his crops flourished. Ever since, farmers in these parts invoke San Ysidro for good harvests.

There was Evelyn, straddling a makeshift ladder, slathering layers of mud on the old church, going on about how she wasn't going to play the organ for someone's funeral because, dammit, the old man, she wouldn't say who, had never done anything for the church, or for anybody else for that matter.

Years later, when Ole Man River Gene and his band fired up "Ring o' Fire" in the middle of our horse corral during my wedding reception, the Corrales police showed up to address their concerns with the volume. We were able to win a few more songs-worth when they discovered Evelyn's pie was for dessert. Evelyn and I have been good friends ever since.

The Curtis-Losack Farm sits squarely in the village of Corrales, three and a half miles in and three and a half miles out, sprawling eastward from

the main road toward the river. You have to go by here to get wherever you are going. If you're not careful, though, you might pass right by it; it's not the kind of farm that commands attention. You'll have to want to see it, but then you will really see it.

A tin-topped adobe barn sits next to a pond filled with mean geese Evelyn grabs by the neck to hug and wild ones just passing through. An orchard of living, breathing trees hangs heavy with cherries and fat peaches; green, yellow, red, and burnished crimson-black apples; smoky-purple plums, pears, and quince. A chunky plot of working dirt is rowed and furrowed with the old crops—blue corn, New Mexican hot chile peppers, and squash lined up next to heirloom tomatoes, colored carrots, and okra. A back porch off the main house is filled with projects—fruit leather drying, chile being tied, vinegar aging. Inside, something is always on a slow stove. There's room to pull up a stool at the kitchen counter. There is life here. It is a forever place.

During a recent community Farmland Preservation Committee meeting, Evelyn nudged me and whispered that she wasn't planting any vegetables this year because she was too damn old. Goldie, her go-everywhere Chihuahua, grumbled a protest from her lap. She just couldn't keep up with all the work, and her kids would kill her for trying if the field didn't do the job first.

I found myself offering to come and help.

"Really, honey?"

Wayne, the committee chairman, looked up scoldingly at us from the December minutes he was reading aloud for a vote. "Shhhh, ladies."

"Sure. I'll come help you. I like vegetables."

"Oh, honey, I'd hate for you to go to all that trouble. Wanna come over Monday morning and we'll figure out what to plant? We can have some pie."

From Evelyn's porch I saw that the tractor had already passed through to prepare an acre or so for planting. I had hoped we could have done all this unearthing by hand and sweat, offering the opportunity to understand and appreciate what our ancestors had to do to survive, to build a connection to the earth, to learn what it takes to make something grow. "Oh phooey, honey, that's too much learning," Evelyn blurted. "If you got the equipment, use it."

We head inside the farmhouse to figure out the garden plan. Two big pots of bubbly cherries from a couple harvests ago sputter on the stove, filling the winter kitchen with summer and red. Evelyn stirs the pot; we hover dumbly in its steam like drunken bees, spooning samples. She wipes her face with her shirt sleeve, smearing red dots of jam into little comet-trails across her forehead.

"How about a piece of key lime pie? Will you eat some before I tell you how I made it?"

She turns up Schumann on the kitchen radio, then turns to stuff cherry pits into a jumbo-sized pickle jar, fruit clinging to the seeds that she wasn't about to let go to waste. A little sugar on top for good measure, then onto a shelf to be forgotten about and remembered, maybe around Thanksgiving, when she'll stumble across a big, happy jar of cherry hooch.

"Fennel!" Evelyn exclaims.

She jumps up and produces a bright white bulb with ferns spreading in all directions from a stash in her refrigerator. "We can grow lots of fennel, honey."

She lops off a chunk and dunks it in a mug of hot water to see what will happen. We dive into dreamy plates of her key lime pie.

"But Evelyn," I had to ask. "There's only so much fennel people will want. How will we sell it all?"

She reaches for her 1949 *Noridge Co. Cookbook*, which the insurance company gave to her and her late husband Johnnie when they got

married. The glue still somehow has held it together all these years, except, apparently, for the part on fennel.

"Maybe we can plant celery instead," Evelyn offers after tasting the fennel water. Back in the day, celery was something of a staple in Corrales. Alejandro Gonzales in fact, right down the road, was known as the Celery King of New Mexico. He was so proud of one year's harvest that he sent a large stash to President Calvin Coolidge as a Christmas present.

Evelyn disappears into a darkened pantry room off the kitchen that she calls "the den of inequities." Here is everything a cook would ever need: flour in sack cloths, sugar, baking soda in bulk, stashes of teetering egg cartons, more jam on a back-up stove, Cheerios, fermenting cherries.

"Don't worry, honey, about a garden plan," she reassures from the other room. "We'll just plant what we can and see what happens.

"And the secret on that pie is a jar of Dream Whip. The marshmellow creme. Just mix it right in with the key lime part. You don't have to tell people what you put in it."

In a flourish, Evelyn emerges from the storeroom, then disappears around the corner and out the farmhouse door. There, spread out from the barn toward the mountains, a big chunk of raw earth awaits, like a whole new year laid out for us. Beyond, an orchard filled with apple and pear, peach and plum trees, is just starting to come back to life.

I follow her out the door.

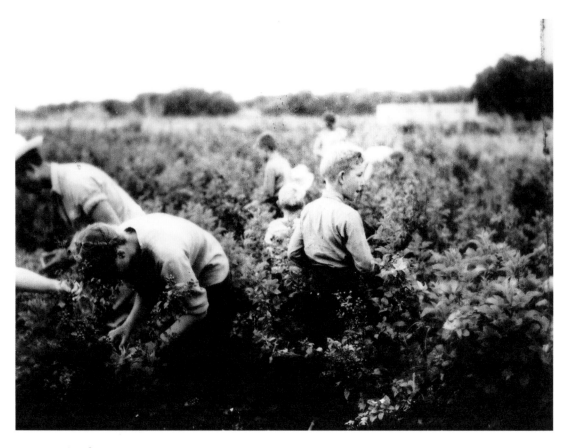

Black Berry Patch
Evelyn + Johnnie week they
met

THE BLACKBERRY PATCH

"Honey, are we gonna save Corrales?
Well all I know is I'm going out raising hell."

ONE OF EVELYN'S FAVORITE THINGS TO DO away from the farm, besides going to the opera or the dollar store, is to drive around her village of Corrales. One day I go along for the ride.

"I think St. Anthony or St. Christopher or whoever he is jumps out the window when I drive," Evelyn says, scooting me over to the passenger side. She's been driving since she was twelve. Everyone was too busy on the farm so she just drove herself up to Mrs. Mims in Bernalillo for piano lessons.

Evelyn drives around as if nothing's changed, as if all the old farm roads are still old farm roads. Goldie lies sprawled out across her lap, the windows all down; she tops out at ten miles an hour despite the line of cars snaking behind us on Corrales Road.

She scans the landscape like her scrapbook. A life unfolds a story at a time. Most pick up somewhere in the middle and trail off into tangents as if no one ever died or anything ever changed.

Evelyn sees the house where she was born in a crumble of adobes, shrouded in weeds, on a little rise in the land. She passes old alfalfa fields she mowed as a teenager in a contest with Tony C de Baca to see who could create the prettiest field. Midnight Christmas bonfires still light our way. She crosses old bridges no longer there.

Evelyn sees in that way older folks do when they look at the place where she grew up. They see past whatever is there and whatever is no

longer there. The here and now, other people's lives, seem to have no power of presence over the world they know.

This is a story about Evelyn Curtis Losack, but to know Evelyn, you have to know Corrales. They share the same heart and blood— the land and its river.

"C'mon honey, let me show you around."

Corrales is a saved place. It's surrounded by city—Albuquerque to the south, Rio Rancho to the north and west. Metropolis comes all the way up to its borders in the form of tire stores, Thai buffets, tattoo parlors, getfitfast. When the weather's nice the guys at the car stereo store open their bay doors and crank the sub-woofers, causing cars stopped at the traffic light to vibrate.

But something starts to drop away as you cross the river, leaving the city to the south and east behind. The four lanes narrow to two and slow down. Stoplights fade away. You follow and let go. Time is not of the essence here.

What you notice first is how the browns and greys of the wide-open Southwest yield to the greens of fields, pastures, and orchards of the valley. Trees narrow the view.

The source lies just to the east. Hemming the whole seam of Corrales is the Rio Grande, carrying water from the mountains up north through the village and southwards to the sea. A rich, green floodplain flairs out from it through the valley, beyond which belongs to the desert.

The grand river once engulfed the land like it owned the place, which it did. Epic floods unleashed through the valley for centuries until a series of dams, levies, and drainage ditches were built. The river was straightened to the will of humans and channeled into a tamed existence. Yet this is still the river's land.

Rising to form Corrales's western border are the sandhills. This is where villagers took refuge one winter back in 1904 when Evelyn's mother,

Dulcelina Salce, was just an infant, and one of the Rio Grande's epic floods hit. Folks were reportedly warned of the impending mad waters by a Pueblo Indian who heard the river roaring past him. As many houses in Corrales became submerged, residents decamped to the west, constructing a shantytown of improvised tents and dugouts to last until the land dried out in spring. The sand dunes today are barely distinguishable, having dissolved over the past couple generations into platted subdivisions with xeriscaped yards of rock and desert plants.

Atop the sandhills sits the mesa, now the city of Rio Rancho. Up until a few decades ago, the area was blanketed in native grasses forming the common grazing area of this region. Evelyn remembers getting on her horse as a child and riding for hours across the seemingly endless expanse of mesa. I recall flying in a small plane over it when I first moved here. Looking down, I saw how the land had been graphed with roads to nowhere among the sagebrush. Within a few years' time those irrelevant roads led to residences, the blanks of open land filled in.

Evelyn and I pass the old dance hall, the one-room schoolhouse, the cottonwood tree where at least one man was hanged back in the territorial days. We pass the Rancho de Corrales restaurant, in former days the old Eschman orchards. Evelyn used to pass by here on her way to school, a line of blond German prisoners of war looking back at her from their labors digging ditches and clearing fields.

We pass some fields that Jimmy Wagner farms, planted now in a spiral maze of corn that children wander through in the fall. Evelyn motions to the west and says casually, "There's the old Indian pueblo." I follow her gaze, but there's nothing there, just a house and a dirt road. Take away the house and the dirt road and I start to see how the land swells into a rise, not quite a hill but definitely something intentional and unlike the land that surrounds it. Before Spanish explorers arrived in 1540, the Pueblo Indians occupied this and much of the Rio Grande Valley for centuries, tending corn, melons, and squash in the fertile alluvial flats of their

P'Osoge, the big river. It's not unheard of to walk after a rain or through a freshly turned field and come across a pottery shard, the black and ochre designs the geometries of an ancient ceramic tradition.

Dreams of cities of gold lured the Spanish here. They settled the valley along the Rio Grande with their new animals, crops, religion, rhythms, and language. They mothered, too, an anatomy to this place which can still be seen. Long strips of land originating at the river stretched west across the valley and up and across the mesa, giving land owners and large families equal access to the fertile riverbanks, the cottonwood and willow trees, the irrigated land of the valley's floor, and vast grazing grasses of the mesa beyond. With each new heir, another strip of land would be peeled off the family's original section, so that after several generations an individual property here might only be several feet wide.

It used to be that everyone in Corrales farmed. The dirt road to get here was more dust and bumps than road, and you had to cross a rickety bridge over the Rio Grande first. That started changing when Corrales Road was paved in 1946. With a smooth road and a new bridge, folks wanting to escape town for country started moving here. Artists and university professors, scientists and free spirits soon joined the farmers. The population grew from a few hundred around the turn of the twentieth century to around eight thousand today.

Except for the time last century when Alejandro Sandoval got the name changed to "Sandoval" to honor his father, this place has always been known as Corrales, meaning corrals. The name still fits. It's not unheard of to have to stop and help round up a loose horse or bribe a bull that's wandered into the middle of the road back to his corral with some fresh apples. Village council meetings are often dominated by heated debates on how to coexist, or not, with coyotes. People here ride horses on weekdays. You can't give your fresh chicken eggs away since many of your neighbors already have too many of their own. There are miniature donkeys, peacocks, bees, guinea hens, rare species of sheep, pygmy goats, heritage birds, rez dogs, ducks and

geese, feral cats, skunks, even a Texas longhorn named Valentine in honor of the heart-shaped mark on her rump. She somehow had her baby calf on Valentine's Day. It's one big symphony here when a fire truck wails.

Along the river is the bosque, hundreds of acres of beguiling woods of old cottonwood trees, willows, olive, and tamarisk that are home to red-tailed hawks and chicken hawks, possums and porcupines, and the bald eagles that return each November.

You lie in bed warm and secure and outside the night can still belong to the other. Coyotes circle and circle closer, surrounding their prey. One starts to howl then another, then five and then the whole pack crescendos and you realize you're not alone, and then it's completely still again. The wild turkeys descend by dawn; you look out and there's one in your tree, and you think, Where did that come from and why is it here? And what do I do now?

Corrales is a determined little village that finds its own way. We have cake walks to support our schools. Our mayor dresses up in a giant bunny suit and leads kids around for the Easter egg hunt. We dress up our animals and walk them down Corrales Road whenever there's a parade, which is quite frequently. Many of our roads are still dirt, and watch out if you try to pave them—many folks like it that way.

Corrales is where you get 10 percent off if you ride up on your horse at the Village Pizza, where the police have been known to shoot at moving vehicles, where people cry and write letters to the editor and leave mementos when a beloved old tree falls. We don't have a grocery store, but we do have the Frontier Mart, where you can buy lottery tickets, locally made wine, fresh hot tamales, kites.

TC's Tijuana Bar, an old adobe with creaky wooden floors, really cold beer, and walls so thick you don't notice what's happening on the outside, is the place for lunch, as long as TC hasn't skipped out to go fishing. It's like going to your uncle's place. Regulars include Corrales's work-at-homes, the retired, the mayor, ditch diggers, artists, and those who move a little

slowly and boxily in their Carrharts stiffened by spring wind, summer monsoon, horseshit, and sweat. Everyone comes for the chile and to chat with TC by the bar, get warm by the big fire, and catch up on the latest news from a TV that's always on with the volume muted.

Evelyn and I cross back and forth over Corrales's original *acequia madre,* the ancient mother ditch the Spanish settlers constructed to move water from the Rio Grande to fields, orchards, and gardens. More ditches and channels have been added, allowing agriculture to flourish. Cottonwoods and other trees grow along its banks; ducks and nutrias, snakes and crawdads seek out its cool waters. People do, too, drawn to its shaded banks and the flowing presence of life. It's where Evelyn learned to swim as a child, dusty kids jumping straight from the fields into its cool waters at the end of day. She almost drowned once trying to swim in the still waters of a stock tank—she only ever knew water to be moving. It's said, though, that if a child strays too close to the acequia's waters, La Llorona could rise up and snatch him away. At night, you sometimes hear a faint, mournful wail coming from the ditches. The ghost of the Wailing Woman cries out as she searches in vain for her lost children.

Roaming through the village, you discover fragments and echoes from another time tucked into the fields. A red tractor with an engine you can fix at home; a stand of fruit trees planted by someone no longer alive; a collapsing handmade bridge over a stretch of hand-dug ditch—soul marks on open land not yet erased by development grids. I once watched a man pushing a tombstone down the center of the road to the cemetery. I found out later he had carved it himself for a friend who had died.

There's an old ark moored along Old Church Road, hidden behind tall fronds of salt cedar dusted pink in spring, bronzed by autumn. Captain Pete Smith built it by hand many years ago so he and his wife could sail down the Mississippi and out to sea, but his wife got sick and died,

and their boat has been moored here ever since. Little wild quails dart back and forth in front of it like they're late for something. Looking at it one way, it's an unseaworthy, rusting steel hulk. But through my son's four-year-old eyes it's an ancient pirate ship.

Recently I ran into Ralph Martinez, whose family owned the land where our house stands now. Growing up, he helped his grandfather farm it with a team of horses. Over the years, the children of farmers have occupied a different time, needing their own houses and something more from their land than crops. Many of the fruit orchards, vineyards, and alfalfa fields that once defined this community have folded back into the earth and reemerged as homes and neighborhoods.

By the time I moved here in the mid-1990s, just three of Mr. Martinez's old apple trees remained on our property. My family gathered the apples and made earthy cider and pies, but despite tending to the trees like grandmothers, time took over. The pruner came out and told me, "Ma'am, it's time." One by one, they got too old. Limbs fell and became slow-burning fires. Trunks hollowed out and housed unsettled crows. The last tree fell after a cold winter's night and the big wind that followed.

Evelyn pulls up outside Casa Vieja, a centuries-old, low-slung, sprawling adobe house that is now a restaurant. Some say back in the early 1800s tightrope walkers came up from Mexico to perform in the courtyard around bonfires in and out of the night's shadows. At various times the property housed Spanish soldiers, served as a courthouse, a stagecoach depot, a grocery store, a psychiatric hospital, and a family's home before settling into its latest manifestation. Ghosts and rumors of hidden treasures within its three-foot-thick walls still linger.

The restaurant owners, who smoke bacon and steep vodka, work to keep the place alive even as the elements work to return the old adobes to the earth. They're also trying to keep the local farms and gardens

thriving. Josh, the chef, can be seen poking around Evelyn's farm, gathering downed apple wood to smoke his meats, goose eggs to richen his baked goods, basil, fresh radishes, advice and old stories. Evelyn even gave him a start of her apple cider vinegar that's been in the family for over a hundred years.

"Here, honey, run these up to the back door and see if they can use them." She reaches in the backseat for a basket of flowering garlic green onions. "And don't charge them anything. They're trying so hard."

We drive past the patch of land where Evelyn's paternal grandfather, Andrew Sword Curtis, passed away. A hardworking Scotsman, he rose early for his half-hour of prayers and half-hour of exercise, repeating the ritual at the close of day. He was determined to take care of his body and soul so he would always be there for his wife. He planted an orchard for his family in this spot so they'd have something when he was gone. Evelyn remembers visiting him one morning, how he had big plans for building a turkey coop. That afternoon he died.

At times back home in Indiana, I'd be in the car with my mom and grandma. Nana would point out a fragment of concrete. "There. Over there. Your grandfather built that." Not the remains of a building or a house but the concrete itself. An unnoticed curb along the way, a strip of sidewalk through a neighborhood, a small wall around a courtyard. The simple but necessary, taken-for-granted constructs of a city, holding, too, the story of my family. My mom would remember how she and her sister would pile into the car Sunday evenings as their father, John August Schwert, drove around downtown to his work sites to light the lanterns. How he would sit at the kitchen table during the Great Depression, hunched over papers and quotes, worrying to himself in his native German, trying to figure out how to find the jobs to get the family through.

I haven't passed by those places in a long time. I wonder if they are still there. I no longer live among my grandfather's walls.

Just beyond the old church across from the cemetery is the spot where Miguel Griego tended his fabled cherry trees, planted in 1914. Something about those trees in that place. There was magic. In June, they filled with big, sweet, dark red cherries. People would come out every spring to help harvest. Children, red-stained, swayed from the treetops. One tree grew so big the local newspaper, the *Corrales Comment*, came out to measure it and take pictures. There's no trace of the trees today, just a story that some folks around here still remember about how summer used to be. As Evelyn and I pass by, we notice a realtor's sign plunked down near where the trees used to grow. It declares in bold script: "We know Corrales."

We pass by a slumping abandoned house off Coronado Road. It was known as the old house on Coronado Road when Evelyn was little, so by now she calls it "the pretty damn old house on Coronado Road." Like many houses at the time, it was made from sod bricks—*terrones*—cut from the banks of the river. Evelyn isn't sure who owns it now.

Back in the early 1940s, someone did. The Losack family moved into it when they left Texas, where they had grown cotton and melons and whatever else they could do to survive. Mr. Losack thought there might be money to be made off natural gas in western New Mexico. For some reason lost to Evelyn, they never made it farther west than Corrales and ended up in the old house on Coronado. Adjacent to it is the land they bought to farm. I've always called the building there now the old Village Mercantile, since that's what was in it when I first moved here. When the Merc moved to a bigger place down the road, the space was taken up by Curves gym on one half and an Episcopal church on the other. It's a quilt store now.

Evelyn pulls into the gravel lot. Guinea hens dart across the dissolving remains of the stone labyrinth the Episcopalians built out back. "And here's the blackberry patch," Evelyn's eyes alight, and she tells me a story.

Back in the summer of 1946, when Evelyn was seventeen and the war had ended, her little sister Dorothy was good friends with the

Losack girl, whose brother Johnnie had just come back from serving in the marines. He was tall, dark, and handsome. One day the sisters visited the Losacks. Evelyn and Johnnie picked blackberries. He built them a bonfire. Soon Johnnie became "my Johnnie," and within three years they were married.

Further down the road we pass Evelyn's farm, right in the soul-center of Corrales. It sprawls to the east: farmhouse, barn, field, orchard. The house where Evelyn grew up sits just to the north of where she lives now. Along the front was the porch where the family's bustling farm stand used to be. All across the second story Evelyn's mother Dulcelina would hang her red chile *ristras*. People from town made the long trip to Corrales to stock up on bushels of apples to sauce for the winter, cucumbers to pickle, corn to dry, chile to roast and freeze, potatoes. The family never got a full dinner Saturday nights as every few minutes a customer would pull up to purchase produce.

After Evelyn's father died the house was divided up into apartments. The kitchen is now the back of Apt. B. The front was where Evelyn and her family would put up the Christmas tree. The farm stand is now a storage porch for the tenants whose rent helps keep the farm going.

So much has changed here. Every generation redefines the land; its shape shifts with time. The value of land changes with the community's values, with weather and geography and circumstance and economics. Houses over orchards. Yards over fields. No one still buys apples by the bushel.

But something constant seems to endure here despite change, or perhaps alongside it, something that allows Evelyn to see past the labyrinths and parking lots to the sweet, fat blackberries instead, to her husband and the whole wide world that was once open to them.

Land possesses a memory of what grew here and the dreams that

formed it, of its beautiful, tragic dance with mankind. A spiritscape is embedded in the landscape, unseen at times but always felt. The old farms and endless orchards and fields starting green and strong by the river and dissolving into the wide-open mesa are this village's phantom limbs that can't be forgotten any more than the sky above. We can no more take that spirit away than hold on to it. It is deathless. It is the story of our time in this place.

I look over at Evelyn, looking around her home. She belongs here. She belongs to here.

I have this dream sometimes. I am moving through Corrales on a bike, walking, on a horse, floating. And I come to a part of the village that I don't recall. The road winds around long fields past streams and then narrows, softening under a green canopy of cottonwoods. I turn down another road, and it's the same—golden fields and burnished orchards. The road just goes forever. I feel free, I am home. Always the dream comes just as I wake up at dawn. I can only just lie there afterwards, trying hard to figure out where this place is. I even drove around once on back roads through the village trying to find it.

Here I am, floating round the world, dreaming of my place. Here is Evelyn, plunging her arms deeper into the earth, knowing of place.

Evelyn drives past the old Gonzales field next to the library and the park. Since the Gonzales family acquired it in the early 1700s, and for centuries before, this land has always been farmland or open field. Then a couple years ago a for-sale sign went up. Talk was of turning the crops under and building several houses on the land, but something pushed villagers to want to save it. Enough money was scraped together, grants sought, bonds approved for the village to purchase the land; development rights

Haystack adorned by best friends
Roberta Alary and mother Dulcelina
Salce, 1920's

Evelyn's flower garden

were sold off with a conservation easement. It will now always remain farmland and open field. The property joins scores more acres of farmland and open space in Corrales under easement and saved from development. In a time when land is valued for what can be done to it or the income it can generate, this land is valued for what won't be done to it and how it won't change.

On our way back to the farm, we pass by the old Bessom's Flower Shop along Corrales Road, where Virginia Bessom operated her business for over twenty-five years. It's now the school where my son August goes. They saved Virginia's old greenhouse to use as the environmental ed class and the talent show stage.

Evelyn pulls into the gravel parking lot. "You know, honey, this spot used to be my mother-in-law's potato patch many, many years ago." She recalls that when the Losack family moved to Corrales, Johnnie's mother Martha was determined to plant potatoes in this stretch. The county extension agent was skeptical, due to the clay soil. But she told him, "I have nine kids to feed, I have to do something." She rose every morning at 4:00 a.m. to make bread, and was out to the end of a row by 5:30. Her potatoes grew.

I hope I have the same luck with a potato patch off Toad Road that my friend and I just planted. Turns out Evelyn's Auntie Lena used to grow on that land, too, years back. She used to farm in nothing but old jeans and a bra. Lately, sprigs of Auntie Lena's rangy and tough alfalfa, the last crop she raised, have been popping up all over the field in between our young Blue Peruvians and Creamy Dutch new potatoes. I ask Evelyn if it'll take over. She tells me not to worry about it, let the alfalfa be. All the stuff that came before still hanging around will be good for our potatoes.

PLANTING TIME

<hr>

"You know, plants get notions of their own, too."

IN NEW MEXICO, SPRING MEANS THE WIND has built up in the west and is moving in, a wild wind that seems to have come from the beginning of time. The tops of the trees are the first hit. By the time the wind meets ground, it has transformed into mad swirls of dust and sand. Most people go indoors and stay there until it passes. But on a farm you can't get away from it. If it's too intense and too early in the spring, it can blow all the snow and moisture away in the mountains as if winter had never happened. Then there's no snow to become water to drain into the rivers, to come into the fields. It can rip the blossoms right off the fruit trees. Knock the wind right out of leggy, new seedlings that aren't yet rooted enough. You learn once again how everything can just disappear, blow away and return to dust.

The morning wind was like that on the day my dog died. It was the spring equinox. Little Bo Peep had been diagnosed with an incurable tumor, and it was just a matter of time. After the wind had died down enough, I took her down to the river. She slid into the shallow waters of the nearby acequia, her favorite place on earth, for a swim. She splashed, wagged her tail, took a long sip of cool water, fell to her side in the gentle current, and left this world. In her own way, on her own terms. Quickly, muddily, peacefully, happily. I took her body, the water took her spirit.

The space left without her was without boundary. The field I had planned to help Evelyn plant was ready; winter had finally broke. It was supposed to

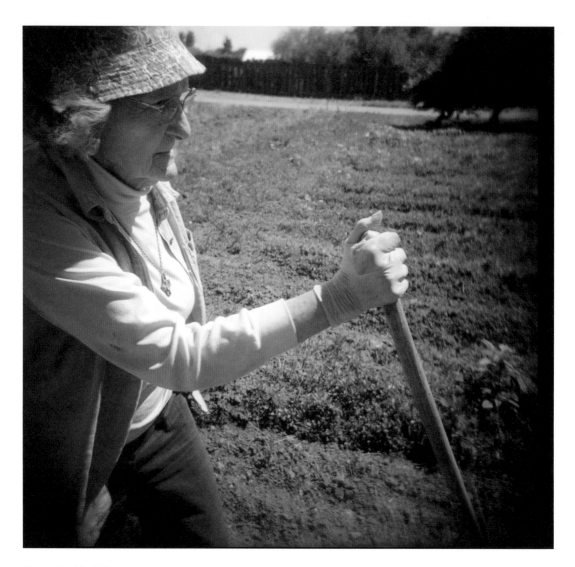

Hoeing the chile field

be time. But I couldn't think of planting, I didn't want to think of the future at all, since that would mean roping off this past, letting go.

I emerged a few days later and stopped over at Evelyn's, hoping she wouldn't get the seeds out. As with most mornings, she had a guest already. Mary from the Historical Society was on the couch, buried under Curtis-Losack scrapbooks and albums, hitting Evelyn up for some old photos and stories. Evelyn lingered a while over a tiny black-and-white photograph of a baby dressed all in white, lying in a casket. Armando Vincent Lewis Curtis, Evelyn's baby brother. I had not known of him. Evelyn was around ten when Armando, then a month or two old, came down with the whooping cough. He died within days. He was the youngest child, the only boy. Evelyn says it was the only time she ever saw her father cry.

More stories now, and we don't plant.

Days pass. The seedless rows in the field line dutifully east to west. It was a year ago today when Evelyn's oldest son, Lyle, passed away. He had been sick, but his death was unexpected. Evelyn somehow managed to play the organ at his funeral, all the way through. I arrived this morning to see if she was ready to plant; I called out to her from the kitchen. But I think she spent the day in bed. It wasn't time yet.

It's the last day of March, and the phone rings. "Let's plant, honey." Evelyn had, in fact, already been planting, since before the sun came up. The onions she'd scoped out at the Alameda Greenhouse earlier in the week had looked a bit piqued and dried out, so the clerk didn't charge her for them. Evelyn said she'd come back and pay for them in the fall if they ended up growing.

She put me to work helping hide the rest of her large onion stash under some blankets on the porch. This is a routine Evelyn plays with her children, who get a little nervous thinking old ma is out trudging

over rows in the field and could tumble and no one would ever find her. She hides the evidence that she's planting. It was the same with her mother, who decided to call it quits with farming when she got to be in her eighties. People would ask Evelyn how her mother was, and she'd say how she wasn't doing too much anymore, keeping to home. And they'd say back, "Oh, well that's funny, because I saw her out hoeing on the north side."

I brought over my glossy seed catalogs, but Evelyn had no use for them. "Honey, just go to the dollar store. You can get three seed packs for a dollar. Don't pay more than a dollar, it's just not worth it." She pulls out her stash of seeds, including some she saved from a watermelon she had bought from Thomas, a man who buys watermelons from farmers in Texas and resells them here before ours come into season. Every summer, Thomas pulls his old brown truck over on the side of the road at the edge of Corrales, drops the tailgate, and sets out his sign: "Watermelons. Blessed by Jesus."

"We'll see how blessed these are," Evelyn says, dropping some seed and hoeing a big clod of dirt to cover them. With a random collection of thirty-three-cent seed packs in our pockets we head down the row. Evelyn leads the way, dragging the hoe through the fresh dirt; I follow on my hands and knees, dropping seeds into the rows of soil. We plant the field this way.

Evelyn's body is still muscular but a bit gimpy from years bent over battling Siberian elm trees from taking over the farm. Sometimes she'll find herself in a certain position in the garden and unable to move her kinked leg. I ask her if that was from a tractor accident.

"No, honey, that's from my stunt water-skiing days. But that's a story for another day."

Just then, our neighbor Jen pulls up in her old blue truck with a big box of half-priced seeds. Jen first met Evelyn years back at the grow-

ers' market when Evelyn convinced her to buy a handful of sun-wilted *quelites,* known around here as "Corrales spinach," which she went home and cooked a little too long (Evelyn's theory) into a bitter, soggy mess. Jen was convinced she'd been sold a weed. "Well, you were!" Evelyn agreed, "but a good weed."

Since then Jen shows up every spring to plant a row or two of vegetables since there isn't much planting space at her place. Evelyn's had many people over the years plant themselves a row. Typically they last until about July, when the weather gets too hot and the work too hard—fair-weather farmers. Jen, however, still shows up.

We plant thick—this isn't the time to be thrifty, Evelyn will tell you—sowing multiple seeds in each hole. The germination rate is lower than one might think, and it's better to have to thin later than to have to replant much later and lose all that growing time. "If you're going to the trouble of planting in the first place," Evelyn says, "you might as well plant thick, because you never know."

In the garden, Evelyn relies on the basics: plenty of seed, some water, blind faith, and a sharp hoe. "If you have anything else on hand, it won't hurt to use it, but it's not necessary, honey."

She directs, like a conductor: Add some gypsum to break up the clay soil. Don't plant the blue corn now; wait till later to avoid so many worms. Pile up leaves and debris around the little plants to protect them from all that wind. Knock down the wild mustard since it harbors evil. Plant the chile deep so the roots will go deep and make it hotter. "If you do that the chile will be so hot it'll jar you back to your ancestors."

We finish for the day and it feels good, the simple act of putting seeds into the ground. It tells the earth, "I'm here." For nearly all of her eighty-three years, Evelyn has done the same thing every spring. Different fields, different seeds, different stories, different friends, but always the same thing: plant, to once again find direction at winter's end.

THE FARM

"Please prize the bouquet. Took a long time to grow."
(written above Evelyn's yarrow on sale at the market)

IT'S THAT HEADY AND HOPEFUL TIME in the April garden when the soil has been amended, hoes sharpened, ditches cleaned, winter dead removed, the fruit trees in bud. Everything is planted, and no weeds yet threaten. It's also a waiting time.

This year Easter is early, but we're still in the waning days of Lent, the time of sacrifice and resolution, which means Evelyn has banished all pie and chocolate from her house. With time on our hands we start to plan Evelyn's annual Easter feast, which she always hosts at the farm. She always says it's going to be small this year, just a few people, but then she loses track and starts inviting scores of people from all over the village. One year Evelyn got carried away and decided to make the celebration a traditional matanza in which a pig is buried in the ground and cooked under a fire overnight. By Easter morning, though, the meat hadn't cooked. Evelyn had some neighbors wheel over their gas grills to the farm, and when guests arrived, handed them a bunch of knives saying, "Here, start cutting. Happy Easter."

Evelyn begins to think and mull. All the dishes, the pots and pans, the tents and folding chairs. All the work, the uncooked pork. Would it be better not to have the gathering at the farm this year? Maybe at the park instead? Jen and I just ignore her. It must be the sugar withdrawal talking. Spring could doubtful come to Corrales without Easter at Evelyn's. This place needs this farm.

When Evelyn talks about her grandfather, half-remembered stories surface, things her mother told her over the years. Angelo Salce grew up somewhere in the northern mountains of Italy, surrounded by a bounty of grapevines and fruit trees. For reasons no one exactly knows, he left home when he was just a teenager. Evelyn thinks it was because his family was large, and leaving home was just what you did when you reached a certain age. Angelo traveled north through France, learned to cobble shoes, stowed away on a slow boat, and landed in the New World: Veracruz, Mexico, 1879. He stayed there awhile, headed north, and ended up in Albuquerque, where he joined other Italian immigrants, the Bachechis, the Domenicis, the Franchinis, and the Gianninis.

Angelo worked at his shoe trade until his hands became unsteady due to Parkinson's. He was told to change his line of work to something a little less detail-oriented and he chose farming. In 1889, he found some land in the little Spanish village of Corrales, where, with the coming of the railroad, French, Italian, and German tongues were joining what had traditionally been Pueblo and Spanish. Angelo sent for his brother Luigi back home. They cleared the land, and the farm was born.

The Menicuccis must have felt sorry for Angelo and told him about a young woman back in Lucca who wanted to come to America. They sent pictures back and forth, and one day in 1903 Maria Nechiari boarded a ship and ended up a farmer's wife on the other side of the world.

Angelo and Maria soon cobbled together more land for their farm. Angelo set out to re-create his Italian home of vineyards, fruits, and vegetables. They spent years leveling land made uneven from the clay ripples and locked layers of a densely silted floodplain by hand, shovel, horse and wagon. Angelo would pass on that mission to his descendants, who still battle the same improbable terrain. They sang old arias among their new trees. *La Traviata,* Evelyn says, was the favorite.

Six children came: Dulcelina, Ida, Virgil (Gilio), Lena, Arthur, and Mary. Then in 1918 the Spanish flu swept through. Three people in Corrales died that day; Maria was one of them. She was thirty-nine years old.

Evelyn's mother Dulcelina was only fourteen at the time of her mother's death. She and Ida, then eleven, stepped up to care for the family and help their father. They would rise before dawn to plant sweet potatoes and follow behind their father, who followed behind his horse, planting corn and beans. Dulcelina, who was born of this land, proved more of a farmer than her father. She didn't carry the restlessness of the immigrant who still remembers another place, another way. Between her and Ida they kept the farm running.

Dulce finished school and at age seventeen began work as a teacher in Corrales and in nearby Placitas, sending much-needed money back to the farm for several years. One day in 1928 she was at a rodeo on the old Thompson ranch with her stunt-loving brother when he was thrown from a horse and broke his leg. Just then, a blond-haired, green-eyed sawmill worker named Vincent Curtis ran up and offered to take him to the doctor in town. A Scot-Englishman from Wisconsin, Vincent was from a family of sawyers who traveled to where there was wood in the mountains, sometimes traveling the rails with hobos. Once he met Dulce, he decided to stay.

Dulce begged the county clerk not to publish the marriage notice because married women weren't allowed to work as teachers in those days, but it was published anyway, and she lost her job. Then the Stock Market crashed. Vincent couldn't find much work in the lumber mills. The Depression descended. A flood came. And on April 16, 1929, Evelyn Beatrice Curtis was born.

The young Curtis family survived, so the family story goes, by eating peas for breakfast, carrots for lunch, and peas and carrots for dinner. They traded eggs for milk. They somehow made due. Her sister Dorothy was born in 1931, and the family planted more.

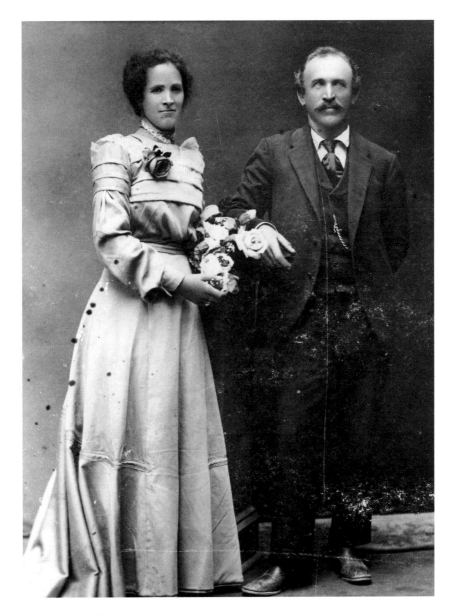

My grandmother, Maria Necchiari,
a mail-order bride, and grandfather,
Angelo Salce, 1903.

When Angelo died after a long illness in 1937, his land was divided up among his children, who built homes and planted their own parcels of land. But the land wasn't enough. During Angelo's time, you grew, raised, made, or hunted it yourself or bartered for what you didn't have. Times had changed and now cash was needed. Everyone had to do something else in addition to farming. Auntie Lena cleaned houses and worked as a caregiver. Uncle Gilio did carpentry work. Vincent found work in the sawmills and paid the taxes for a good portion of the Salce lands. He worked thirty years supporting the farm this way, sometimes only making it home from the mills on weekends. Family members scrimped and saved and planted extensively, adding alfalfa, sheep, cows, and bees as they went along.

Since Angelo's time Corrales had become known as the place for wine and brandy. It all started centuries ago with the Spanish planting their mission grapes for the sacrificial wine at San Juan Pueblo, but soon viniculture spread south along the Rio Grande Valley. When Prohibition descended, bootlegging was one sure way to make it through the Depression. People would venture to the country to stock up. Whenever word leaked out the feds were coming, folks would stash stills in haystacks, submerge them in the inky cool waters flowing through the acequias, or hastily bury them in piles of sand on the mesa, some only recently unearthed as the land was developed. Dulce and Vincent would hide their bottles in apple crates and transport them to the mountain mining towns, where they sold fresh produce and spirits to grateful miners. One time the police pulled them over. The officer was interested in buying some apples. Vincent had to do everything he could to keep him from buying the baskets where the booze was stashed.

Room by room Vincent built his family's house. He cut chunks of hardened mud from the river by hand, hauled them back one by one, and fashioned bricks for the walls. The house began rising slowly up from the earth. Everyone in the family lived in it at one point through the hard times; some even died in it. If there was any extra money, they

added a room or two. But the farm always came first—a chicken coop over furniture, fruit trees instead of paint or curtains. Evelyn learned early on the lesson of making do with what you have.

The barn was fashioned out of the same frugality and improvisation, piece by piece, over time. One layer of adobe mud and brick this day, another one when things allowed. On weekends, Vincent would load up logs from the sawmill deemed unusable but usable enough for a family's farm, then drive them home one or two at a time in the back of his pickup. They still crisscross the ceiling of the barn like old canoes.

Years of damaging floods, hard freezes, and changes to the water table level affecting the soil's alkalinity degraded the quality and quantity of Corrales wine by the 1930s and '40s. Prohibition, the Depression, and increasing wine-producing competition from California didn't help, either. Something more was needed if Corrales farms were to survive in new times.

By the mid-1940s, Dulce and some other farmers had the idea to blanket Corrales with orchards of fruit trees. Villagers pooled their money and placed a big order with the Stark Brothers out of Louisiana. Some ordered just a few trees, others entire fields worth.

Soon Corrales's reputation grew as the home of the fruit orchards. Peach, plum, and pear; dreamy big cherries; but especially apples—at least twelve different varieties. Fruit and produce stands went up along the side of the road. Trucks on their way to bigger destinations passed through Corrales and loaded up with apples to sell elsewhere. Grocery stores carried local fruit. The Salce-Curtis Farm apples were known far and wide; Dulce became known as the Apple Lady.

Evelyn was a teenager when she helped her family plant their orchards. That's about the time Johnnie Losack started showing up at the farm to help Mr. Curtis with his projects. Dulce wasn't encouraging of her daughter dating. She had seen too many people marry early and abandon their education. She wanted first and foremost for Evelyn to go to college, which she did on a scholarship to the New

Mexico College of Agriculture and Mechanic Arts (now New Mexico State University) in Las Cruces. Johnnie had been adamant: no college for him. He had had enough education in the military. But Evelyn was serious and intended to stay. By the winter semester, Johnnie had packed his bags and enrolled.

The couple married, the children came along. When Johnnie got a job at White Sands Missile Range in southern New Mexico, Evelyn took a job teaching music. The young family returned to the farm every chance they could over the next twenty years. Weekends, holidays, and all summer long. Johnnie called it the three-hundred-mile umbilical cord.

Evelyn's father Vincent died during a bad drought in 1962. He was fifty-seven. Dulcelina was left to tend the farm.

That drought was one of the worst here ever recorded. Evelyn remembers how the plants would just wither; there wasn't much you could do. There was not enough water in the acequias to irrigate with, not enough rain. And then, there was the wind. It would whip across the land, whip up more heat, whip the back of your legs while you walked. You kept your head held down.

It was so dry then that Dulce would take out the old truck, the same one they used as the village fire truck, fill up the thousand-gallon sprayer, and drive through the orchard to water twenty-five-hundred trees, carrying buckets by hand to the trees she couldn't reach. If the orchard was still muddy from the last irrigation, the old truck would get stuck, and there Dulcelina would stay until she could figure out how to become unstuck. No one was around to pull her out. And the drought went on.

She struggled with the irrigation pond, the well, the bugs, the invasive elm trees, the heat, and the cooler always breaking down, leaving the apples to rot. Room by room, she divided her home for renters, moving into a little room in the old barn. The income on the house subsidized the farm. The farm always came first.

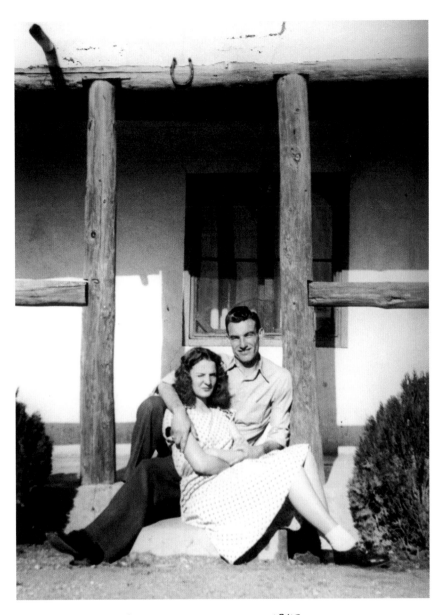

Johnnie and me before our Wedding, 1949

Dulce would say to Evelyn and Johnnie: "Are you going to wait until I die to take over this farm?" Her bones were wearing out, and it was time. Johnnie loved the farm. He skipped out on a raise and promotion, took early retirement, and moved back to Corrales in 1977 while Evelyn finished out her teaching contract. He weighed 210 when he showed back up at the farm, and in no time he had dropped to 175. His letters to Evelyn described all he was doing: slaughtered a cow one day, pulled out elms along the Winesaps, fixed the fence, picked 1,500 bushels of apples all by himself when he realized they weren't going to make it otherwise. Finished a barn.

Evelyn soon joined him in Corrales. It was 1979. She found the place had changed. More newcomers, a few more roads paved. Intel was building a huge plant nearby. A lot more houses; a lot less farmland. Her family's, in fact, was one of the few big farms remaining.

When Dulcelina passed away at ninety in 1995, Evelyn and Johnnie inherited some eighteen acres. They took it over with all their hearts. Whenever Evelyn would say this needs to be done or that needs to be fixed, Johnnie would whip out a little notebook from his bib pocket and add it to the list. Cross it off when it was finished. If someone would ask about, say, an apple order or when the cider would be ready, or if they could borrow a tractor, he'd respond: "You have to check with the War Department," and motion back to Evelyn. He built his family a house. He subsidized the whole farm with his pension.

Then on October 11, 2003, Johnnie died. He had been sick off and on but it was still unexpected.

Evelyn is the farm now. Her children live close by; Mark and his wife Veronica farm their own little piece of land here in Corrales. Joneve teaches music in the schools by day and helps on the farm by night and every summer. Vince owns a company in town and helps whenever he can, especially during pie-making time and whenever the tractor needs to be driven or a field plowed. The grandchildren show up from time to

time to help with the growers' market or to press cider. Everyone has their own lives.

Easter morning came, and of course Evelyn had the celebration at the farm. She rose way before dawn, baking pies from stored winter squash and roasting hams and turkeys. She clipped some apple blossoms for the tables under the big pecan tree, resurrected the Mr. Coffee from the cupboard, and iced the cider. She put on some Bach and deviled eggs in her housecoat.

Promptly around 11:00, people started to show up. Neighbors, family, friends. Christians, Jews, pagans, the folks down the way she's worried about. Pauline Eisenstadt, the ex-state senator, brought her zucchini pie; Jen, her sangria concocted out of moonshine wine. The quiet man brought honey from his bees.

Last year we all gathered in a circle outside, holding hands. Drew Richman sang a prayer in Hebrew. Pauline read some words from Gandhi and Martin Luther King Jr. We fit here as if we all belonged.

We took a picture then. The photograph is always taken from the same spot, and its image defines Evelyn's world. This is what you see: Barn on the left, plum trees on the right. Vegetable garden in the foreground, field in the middle, apple orchard beyond. Mountains frame the very back, pecan trees frame the front.

This spring the weather was still a little brisk, so we lingered inside about the warm stove and cooling pies like grandchildren. Evelyn's son Mark stood looking out the screen door. I asked him something about the greenhouse he recently built at his place, but he was somewhere else. He looked past the yard and Easter tables, past the garden and the field. He was seeing all the way back to the long rows of cucumbers and chile he once cultivated with his grandmother when he'd moved back here at seventeen to finish high school and help her with the farm after his grandfather died.

"It doesn't seem that long ago, but I guess it was that long ago." He turned and headed out to the barn for more folding chairs.

Somewhere on this farm, Evelyn's little brother, who was never born, is buried. After working hard one day, her mother miscarried. The fetus was very small, but most everything was already formed; they could tell it would have been a little boy. Evelyn and her sister buried him in a matchbox under a tree that's no longer there.

Past, present, future, the living and the dead, everything Evelyn's ancestors worked for. It's all here on this farm. What we can see, what's right there in the image, and what is just-to-be-believed.

Six generations have now been born here. It is a place made over time. A house built over the years, room by room, and then taken down over other years, room by room, and made into something new. A field that once was just a field, then planted in alfalfa, then trees, then cucumbers and chile, now sits fallow, just a field again. But it's still the farm.

I have never been to the end of Evelyn's farm road, past the last of the orchards, past her sons' places, to the old farm boundary. Instead, I just imagine what it might be like, how it opens up to the sun, to fields of bright green that stretch beyond. I like to believe the farm has no end.

Corrales has changed much since Angelo arrived, even since Dulce's time. Toward the end of her life, she would describe one of her favorite memories growing up in Corrales. At sundown, smoke would rise from chimneys across the little valley, telling all in the fields that it was the close of day. That's been lost. Yet despite all the houses, the paved roads, the soccer field, the little spas and art galleries, Corrales still considers itself at heart an agricultural community.

This farm has braided itself into this village over the years. Take away the farm, and the whole place unravels. Take away the place, and its soul unravels.

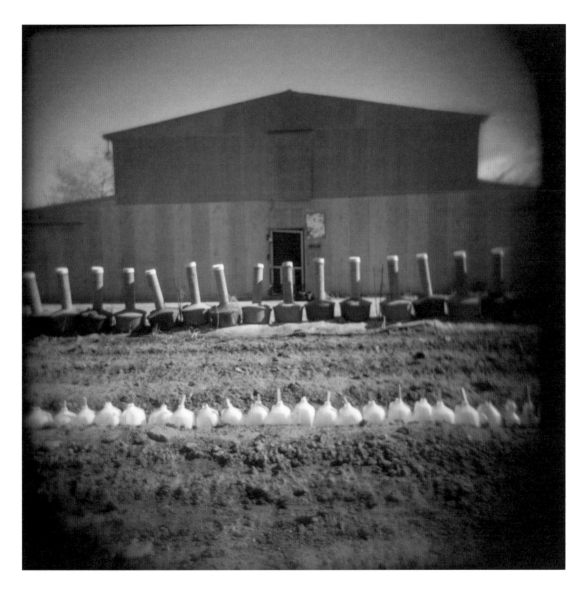

The barn, the old smudge pots, and Evelyn's milk-jug greenhouses

Evelyn calls us back from where we all have wandered. Everyone gathers around her at the piano. She hikes up her apron to better reach the pedals. Her hands meet the keys as if they can't be kept apart, and she launches into "Amazing Grace." We all join in.

"'Twas grace that taught…" Evelyn calls over her shoulder, prompting everyone on the next verse: "And if you're a farmer on this part, you'll really understand—Through many dangers, toils and snares I have already come, 'Tis grace that brought me safe thus far and grace will lead me home…."

There, among the Easter breads and pies, someone has gathered a handful of asparagus just pulled from the field. Despite the lingering cold and the hardened winter ground, the tender little sprigs emerged, portending more good things to come. They line up on the plate, one next to another, their little tips all pointing the same way. All so fiercely fragile, all so bright green.

MORNING WITH THE SPIRITS

"She could make the buffalo on a nickel holler."

RAIN IN NEW MEXICO CAN BE EPIC. One moment the sun is blazing across azure skies. Then the winds wake up across the desert and build, the sky angers, thunder and lightning erupt, and the heavens open up in a biblical downpour. Then it's all over, and everything returns to quiet. The Navajos call this a male rain.

This morning, however, it's a female rain. The land slowly takes in a gentle drizzle falling since dawn. Evelyn decides this is a good time to head to the cemetery down by the old church.

Cemetery visits are for Evelyn as much a part of life as visiting the living. It was her Auntie Ida who would round up the entire family every few weeks while Evelyn was growing up and march them out to the cemetery to plant irises, chase off the rabbits, pull weeds, water whatever was growing.

Out come all the empty Coke bottles, milk jugs, and anything else that will hold water. Evelyn fills them up from the hose and loads them into the back of the old Dodge farm truck. Alan, a regular customer at the growers' market, and his old friend Richard, join us. They know if they tag along with Evelyn and help her water she might just fill them with all the old tales of who's who and who did what with whom.

Somehow we all four and Goldie fit edgewise across the truck's bench seat, Richard having to lift his leg every time Evelyn shifts. Our breaths mix with the muggy air, the windshield fogging so much that Evelyn has to ask, "Is this the road?" not as in whether it's the right road but whether it's a road at all.

Along the single cemetery path we go, graves on either side, some marked with a cross or stone, others just mounds dissolving slowly back into the earth, the markers long gone or perhaps never made. Most tombstones bear Spanish names, but scattered about are some in French and Italian, and a few newer ones in English.

The first stop is Evelyn's Auntie Ida, born 1907, died 1993. The stories come now with the slow rain. You never know what people will remember about you when you're gone, what one or two lines will come to mind to sum up your time here. Ida Salce Gutierrez was a good farmer. She could stand atop a moving horse and lasso wild mustangs across the mesa. She won so many times at the state fair for her produce that she made a huge American flag out of all her red, white, and blue ribbons.

First apples

Sun covers for the berries, sunrise

Evelyn puts us to work gathering all the faded, winter plastic flowers and deadheading the irises. We visit the grave of her baby brother Armando, 1937, who will only ever be her baby brother since dying in infancy.

We pass by a series of graves belonging to a family that Evelyn determines must have been cursed because of all the heartache and misfortune. Richard wants to see the graves of "the women of ill repute" and hear the juicy details, but Evelyn isn't talking. Well, she talks some, but not for long, because she's determined to make sure every blade of grass or wildflower on all those graves of her relatives gets a deep watering.

We visit the man who started it all, Evelyn's grandfather, Angelo Salce, born 1859, died 1937. Dulcelina lost her father the same year she lost her son. Their graves are just a few feet from each other.

Over a ways is Evelyn's grandmother, Maria Nechiari Salce, born 1879, died 1918. When Maria and two others died unexpectedly of the Spanish flu, villagers feared the epidemic's spread. Angelo had to wrap her in a sheet and bury her quickly, then return home and burn everything from her room. Ida and Dulce were away at school, where they stayed during the week. They didn't find out their mother died for a week.

Across from Maria on the other side, closer to the children, is baby Mary, Maria and Angelo's little girl, born 1916, died 1919. She was only two when she died from the whooping cough just a year after losing her mother. Angelo made her tombstone himself, gently etching his daughter's name across the span of the wooden cross.

Many of the tombstones here are homemade. Some have little adobe boxes housing little statues, rosaries, or favorite toys. Others are simple concrete slabs, the deceased's name drawn with an index finger while the cement was still wet. Scattered through the old section are small, whitewashed wooden crosses that Meliton Cordova carved and painted, all 160 of them. He was bothered that so many of the older graves no longer had headstones. He cleared the graves of weeds and carved each cross by hand. It took him a long time.

Richard and Alan keep pressing for more history. "We have no history here," Evelyn quips. "It's all been washed down the river." This is pretty much true considering that several times during the past couple centuries the Rio Grande has flooded its banks and engulfed large chunks of Corrales, taking houses and farmland with it and leaving many parts in perpetually swampy muck. Much of that geography shifted with the damming of the river upstream and the formation of irrigation ditches and flood control channels during the past century, but back in the day the river was the land's architect. One flood in the 1860s was so severe that it washed away Corrales's first church, sending pews and ceiling beams down the river along with coffins from the washed-out graveyard. Since the caskets were made from cottonwood, they floated, and so most were retrieved. A legend in the village has it that a few caskets were opened to reveal corpses lying face down or some with hands raised in horror. Evelyn attributes this to people being buried who weren't completely dead, just in very deep comas or something. Evelyn does love a good story.

Off to the side along the wall lies the sideways grave of Cora Headington, born 1878, died 1958. Cora came to Corrales back in the 1940s from her home in Iowa. She spent long afternoons walking without destination through the village, getting lost, ducking into fruit orchards for shade, and turning up in people's homes, gathering stories. Down at the library is her hand-copied manuscript called "Neighbors of Corrales."

Cora so loved Corrales that she wanted to be buried in its cemetery, but it's reserved for members of the San Ysidro Catholic parish. Evidently some calls must have been made, because Cora is here. Yet unlike the others with their heads toward the western mesa and their feet toward the church and the rising sun, Cora is buried north to south—always a bit of an outsider, but still here.

Evelyn stashes extra bottles of water for future use behind her grandfather's grave. After her grandmother died, it was decided that two of their boys—Virgil (Uncle Gilio, "a real spitfire") and Arthur ("a mild,

Monsoon

gentle, artistic, wonderful man")—would be better off in an orphanage since child raising was too much for a full-time farmer on his own. "Well that didn't last a long time with my Uncle Gilio," Evelyn begins. "He ran away and brought his little brother with him, and when the authorities came after him he hid in a tree. They were right underneath saying, 'We've got to get a hold of that boy. He can't take care of himself.' They finally found the boys, but Grandpa refused to send them back to the orphanage. They just made do."

We make our way to Evelyn's parents' graves. Dulcelina Salce, born 1904, died 1995; and Vincent Curtis, born 1904, died 1962. "Here lies the souls of Corrales," is scrolled across the top of their stone. Next to her father's inscription is an etching of a tree in honor of all his years working at the sawmills. If he didn't do his job just right, the sawyers below could lose an arm or be cut in half. This was Evelyn's father: If he felt his wages weren't fair or things weren't going right, he would go on his own strike. Let the bosses sweat it out while he went back to the farm. Evelyn remembers one time the bosses showed up while she was helping her dad hoe a field of chile. "Vincent, will you come back to work?" they pleaded. He hated hoeing and most farming for that matter, so back to the mill he went—with a raise.

Next to Dulce's inscription is an etching of a chile ristra in honor of all her years on the farm. A month or so after she was born, the summer monsoons fell hard and swelled the river. It surged and spilled over into Corrales into one of those great floods, taking with it houses and animals, tombstones and dreams. Angelo and Maria's little home was taken, too. This was Dulcelina's introduction to the world.

Dulce would tell Evelyn something she had come to learn through life. It's been something Evelyn has struggled to accept: "Do the job at hand and push towards your dream. But you can't change the world. You have to take life as it comes." The river can take your house and everything you know in an instant. Your mother can die one day while you're away at school, and

you won't even know it. Your son can get fatally sick and you won't be able to save him. Your husband can die, leaving you the farm. Drought comes, and the well runs dry, and you water the trees by hand.

Dulcelina died at age ninety, on Evelyn's sixty-sixth birthday. At her funeral, they played a Verdi chorus, "O Solo Mio," which she would sing out in her orchard while working, and "I Did It My Way," which was Dulce's favorite saying.

Evelyn stops at her husband's grave. Johnnie Losack, born 1925, died 2003. "Hello, Johnnie," she whispers close, as she waters the flowers above. Johnnie loved to hunt, and he was good at it. When he returned from the war, he bought a box of twenty-four bullets. Every year he'd disappear for a couple days each autumn, then come back with an elk or deer. In the 25th year of doing this, he said to the family: "Darn! I have to buy a new box!"

Johnnie died on a Friday, and on Sunday Evelyn still had her apples and jam at the market. They were married fifty-four years.

Evelyn puts me to work digging out a plant canister atop one of the graves. Oddly, this was the same job I had when I was a little girl, visiting the cemetery with my mom and Nana. We'd fill the canisters with cool water and pink peonies and old-style roses Nana had gathered that morning from her backyard. At least a couple times a year, and always around Memorial Day, we'd make our rounds to Calvary and then to Holy Cross Cemetery way down in the south part of town to visit my dad, my grandparents, uncles, great-aunts, and others I had never even met.

I learned a lot about where I came from during those visits. Nana would always pack gumdrops and windmill cookies for the drive, and the whole way down we'd listen to her sing her favorite songs and tell the stories of people long gone.

Nana died in 1995, not long after I left my hometown for good. I make a point to visit the cemeteries during the rare times I get back home. But

mostly the final place of my ancestors has become irrelevant to my life, like a lost childhood friend who moved away from the neighborhood long ago.

Evelyn's shirt is wet with the day's rain and her efforts carrying water from relative to relative, as if she were getting them a cool glass to drink. Hers is unnecessary work. She does it just the same. She asks us if we'll look after her grave when she's gone, and we promise.

She has one last grave to visit, that of her son, Lyle, who died just over a year ago. She doesn't talk much now, her stories having faded into the rain, as she weeds around it, gently, like she's pulling the blanket up around a sleeping child. She clears a spot to plant a desert willow a friend has given her, right over where Lyle rests, tucked between his father and one day his mother, like a little boy who's snuck into bed with his parents in the middle of the night.

PARA CORRALES

"You know, everything you do in this life at some point comes back to you."

WHEN EVELYN GETS TO FEELING BLUE or if the weather is too bad to work outside, she pulls up a stool to the kitchen counter, shoves aside bills and leftover pie, and roots around for a pen. She tears off the back of a junk-mail envelope and begins to write. Whatever is bothering her addressed to whomever should know and perhaps can do something to fix it.

"I'm mad as hell, and I'm writing a letter!" she'll announce.

She starts off smoothly, both in tone and script, but by the third line she can't hold back her ire and unplugs. Words become bolder, the slant thicker and tighter, more exasperated; tangential thoughts are crammed in the margins, phrases found lacking slashed. A village councilor, who was undoubtedly the recipient of some of Evelyn's missives, once compared her handwriting to the Pacific Ocean—beautiful, but it moves in waves and then just sort of takes off.

No topic goes untouched or is too sacrosanct. Usually it involves water and the wasting of it. But Evelyn branches out from there. She once wrote a letter to the editor of the *Corrales Comment* encouraging women to buy their men chainsaws for Valentine's Day to cut down the Siberian elm trees choking out fruit trees and native cottonwoods. She composes arguments against people who think the village is a coyote preserve instead of an agricultural community. She has been known to rail at the police for "sitting on their duffs." She even wrote a letter encouraging drivers to take heed of "the fast and flighty" crows who drop tree nuts down onto Corrales Road. (Motorists should yield to the hungry and resourceful crows but should also kindly try to run over the nuts to help shell them.)

Anyone who stops by the house can be asked to read and advise on whether she should actually send such a letter. "Do you think it's gonna get me into any trouble?" Evelyn will ask, softening a bit, seemingly considering the ramifications. But she's always in some bit of trouble anyway, and she's already made up her mind. She's either going to send it off to the *Comment,* mail it to an unsuspecting government official, or read it in front of the Village Council meeting.

Regardless of what's in her letters, Evelyn always signs them the same, mirroring a way she's lived her life: "Para Corrales" (for Corrales).

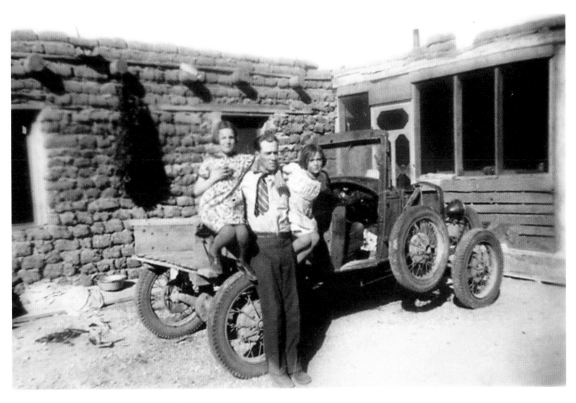

Me, my dad Vincent & sister
Dorothy on a car That dad
put Together with parts.

I spend a late spring morning searching and waiting for water. The potatoes my friend and I planted in the old field down by the river managed to cut through the soil's hard-packed top layer this week. They emerged, thirsty. I arrived at our field at dawn. Running close by is the Sandoval Lateral, the acequia, or ditch, closest to the river. But there's no water in it; someone upstream is irrigating. I will have to wait.

Growing things in the semi-arid environment of New Mexico can be challenging on many fronts, but especially those involving water. Here there is never enough water, never enough rain. Water is not something obliquely sensed somewhere off in the background. Its presence is always noticed, its absence always felt.

Without consistent rainfall, farmers and growers turn to the river for irrigation water or pump from underground aquifers. The Pueblo Indians, who farmed this land for centuries, built makeshift dams and channels to divert water from the Rio Grande. Spanish settlers built upon this with their own irrigation system based on ancient Moorish design. They dug Corrales's first acequia madre over three hundred years ago.

When the snow begins to melt in the mountains around March and swells the river, some water is diverted upstream into the acequias. Side channels, called *sangrías,* create an arterial system circulating the water to fields, orchards, and properties throughout much of the village. The acequias run through October unless the snowfall was bad and we're in drought, in which case the water is shut off and left to stay in the river.

Along the main acequia are check gates used to dam up the available water for irrigation. If too many people are watering upstream from you, though, much of the water in the acequia is dammed up, meaning not enough flow for you to use. So, you wait.

Back in Evelyn's grandfather's time, villagers had to lay branches and limbs across the river to raise the water level high enough to divert it into the ditches. They somehow had to keep the pile from floating away all the while. Capturing water was more time consuming

than time spent actually tending to their crops, and sometimes, if they couldn't maintain the water flow for the whole growing season, they lost everything.

Early Spanish settlers were required to live in fertile areas with enough water for their crops and animals. They were forbidden from polluting the water. They understood water was a valuable resource that needed to be shared. Water was seen as something sacred: a common gift, a common responsibility.

Over the course of settlement, communities in Northern New Mexico were organized around the acequia system, as a life force and a form of self-governance. Traditionally, everyone along the acequia would gather in spring for the *limpia,* to clean the ditches of winter debris. Water is still blessed in ceremony every spring when it first flows through the ditches, through the Indian pueblos and villages along the Rio Grande.

At one time, areas of Corrales on higher ground couldn't receive irrigation, while other areas were swampy from occasional flooding and poor drainage. Plans were developed in the 1920s to expand and improve irrigation and drainage with the formation of the Middle Rio Grande Conservancy District.

To expand the system, land was needed. Many folks weren't happy about an outside group taking control of what had traditionally been a community function, but in the end, Corrales families did surrender portions of their property for very little money in return. Evelyn remembers a response that many in the community echoed: "We're doing it for the common good," *para Corrales,* a sentiment echoed many times over. In return for giving up once-uninterrupted land two new acequias were built and improvements were made to the original system; drainage ditches were dug and a levee built to hold back flood waters. A bosque preserve now stands between the levee and the river, tall with cottonwoods and rich with wildlife.

Just east of the Sandoval Lateral acequia is another waterway known officially as the Corrales Riverside Drain and locally as the "clear ditch." It flows year-round and is home to ducks and geese, nutrias, beavers, otters, and cattails. The stream parallels the river and helps drain the land. Evelyn's father helped cut and carve this ditch in the 1930s. The area was deep in the grip of the Depression, and as part of the New Deal to get people back to work, each family was granted three days of paid work a week to work on the ditch. Front-end loaders and bulldozers didn't exist in the area then; it was all done by hand and shovel, and draft animals if you had them. Vincent somehow got ahold of two old mules retired from working in the mines. He would hitch equipment to the mules, who would help cut through the heavy clay soil. Jumbo didn't want to work so much, so he'd hold back, and poor Dick was left to do most of the pulling. Somehow those mules knew exactly when it was five o'clock because they would simply quit whatever they were doing, turn around, and head on back home dragging whatever was attached to them. Jumbo liked to jump the fence at night. They'd often find him the next day in the neighbor's haystack. This is how our clear ditch was made.

For the Salce, Curtis, and Losack families, it's never been just about your family and your land but about community. Despite holding down a farm and taking care of a family, Dulcelina served as a village councilor for several years; she organized the 4-H and the local PTA and helped start the Albuquerque Growers' Markets and the first Fruit Growers Association of New Mexico. She and Vincent went door to door raising money to build up a cement foundation around the old church to keep it from dissolving away; it took them three years but they did it, and the church is still standing. Dulcelina started the school lunch program with Athaleen Davidson, Josie Gonzales, and Francis Silva, making beans and potatoes to take down to the school. Seniors were invited to join them, and later she helped organize a puppet show and raffle to raise money

for the seniors to build their own center. Along with her son-in-law Johnnie she volunteered for years in water and soil conservation. There's even the Dulcelina Curtis Flood Control Channel on the north end of the village. Perhaps not the most glamorous structure to have named after you, but it's kept the village from washing away.

I see that they're watering the big cornfield up north from our field. This will take a while. Tomorrow the folks downstream get the water, so if I can't get water today, our field of potatoes and fresh lettuces and beans could wither. What then? Pray for rain?

As long as you can turn on a faucet and a steady stream of cool water comes out, everything seems fine. We can't peer down and see the aquifer beneath us shrinking. But this is what we can see: it's hot and dry here, and it's getting hotter and drier. Frequent droughts have always been a part of life, and predictions are they will increase in frequency and intensity. We see less snow in the mountains in winter, which translates to anemic rivers and disappearing streams in summer. Thirsty trees get stressed and become more susceptible to pest and disease. Forest fires grow bigger with more dry fuel. Without trees, erosion sends muck down into the watersheds when it does rain. Whole ecosystems are thrown off. It's a fragile house we occupy.

This year was so dry we had an invasion of miller moths come down to the valley from the mountains in search of water. You'd wake up in the morning and find them fluttering desperately against windows and doors. You'd drive through town at sundown and they'd fill the streets and hit your windshield as you drove, like mad looters.

Many landowners in the valley traditionally have rights to river water for irrigation. When land becomes too expensive to farm and development pressures expand outwards from cities, some landowners sell their water rights and surrender their right to the surface water. When water

rights are transferred away from farmland, it means less agriculture, less local food security, less open space, and less habitat for wildlife and trees. It also means the water is being transferred to support development that leads to more population growth and more demand for resources, especially water.

Everyone wants a piece of the river, as if we can really possess water coursing across the land, underneath the land, through our bodies. It's like trying to hold on to the air we breathe. It's just passing through, on its way to fill the next life.

If there's one issue Evelyn is passionate about it is water. It is her most vital and oldest relative. If you have a meal at Evelyn's, don't worry about staying to do the dishes. She won't let you, concerned you'll waste too much water. She takes sixty-second showers (a little longer if she has to wash her hair that day), then watches as the golf courses in town let their sprinklers go for hours. She sees people giving up their rights to surface water, then mining the depleting aquifers and using clean drinking water to irrigate big lawns or grapevines.

On her eightieth birthday, everyone gathered around at the party for a speech, perhaps something wise or inspirational. Evelyn took the opportunity to rail against the invasive Siberian elms that are choking the life out of the village by sucking up hundreds of gallons of water a day.

Evelyn gets calls frequently from developers wanting to buy her water rights. They offer her big chunks of cash (as in tens of thousands of dollars) to give up her right to water her property. You can imagine how those conversations go.

At times Evelyn can't sleep. She lays awake, descending down deep to the shrinking aquifer underneath us all. She'll have nightmares about water being left on and forgotten. She can't even leave the land in her dreams.

Evelyn has seen the river run dry and fields of food wither. She's heard the sound trees make when hollowed out with drought. She's felt what no rain feels like. She's not taking short showers for herself. We are all connected. This is all we have. Para Corrales.

At dusk, I return to my field. Darkness is closing in, but there is water now. It fills the acequia to brimming. I open up our channel and let it all flow in. The water finds our little ditch and then our makeshift furrows alongside planted rows. Some areas fill quickly because of the low spots. In the high spots, I have to slog through the mud and move shovels of earth from one spot to another to get the water to flow there. The dirt is heavy with water and clay. It sucks back into the earth, not wanting to be moved. It's back-snapping work. Water has its own mind. It will go where it wants to go. I try to stay one step ahead, but most often I'm just following behind.

When the water finally starts soaking into all the rows up to the level of the plants, it's one of the most satisfying feelings in the world. It's all going to be okay, after all, like seeing a weak child eat and drink again.

I watch the water pass through, and for a moment I feel like I had something to do with all this.

TAKING ROOT

"I'd like to order me some of those new apple trees to plant. But my daughter would kill me. All those champions and cameos and pink ladies…"

EVELYN IS SPENDING A SPRING MORNING puttering in her garden when she stumbles across a well-worn iron skillet buried in her tulip patch. She had stashed it there years ago so rainwater could leach out iron for the plants. Lining the skillet is another of her stashes—a sticky

cache of wild cherry tree seeds squirreled away for another time. It was now that time.

Evelyn puts me to work digging little holes for the cherry pits. The task seems more futile than promising. There's a good chance the dried-out pits will never germinate, and if they do, if the little saplings were somehow to survive and flourish, it would take many years before they would produce any real volume of fruit. At this point in her life, why go to such effort trying to start trees from seeds?

I have never actually planted a tree, especially one from seed. I never thought I'd be around long enough in one place to enjoy it. Planting a tree seems to indicate a desire, an intention, to stay. You watch it grow. It watches over you. You become entwined in its cycles. The tree is not going anywhere; leaving is not in its nature.

Back in Indiana, I grew up with what I thought had to be the tallest sycamore tree in the world right in my own front yard. My parents had planted it not long after they built their house following the war. "Turn down Ralston and look for the big sycamore" was how you found our house. Its looming branches and dreamy leaves the size of hands shaded not only our yard but both our neighbors' as well. Its wide, white trunk shed slices of bark that transformed magically into ancient Egyptian pyramids and mud-puddle canoes. Run and wrap your arms around it, and you knew you were safe on home base.

Shortly after I moved to Corrales in the 1990s I went wandering through an overgrown orchard and collected a big basket of apples. I felt I had stumbled upon a secret trove of trees that had somehow been forgotten. Many of them were old and had lived their lives and were on their way out, but their fruit was still sweet, and I made a good pie. I found out much later that they were Evelyn's Aunt Ida's trees.

New Mexico is one of those stop-over places where people come to stay for a while, and then something happens. The joke goes the Land

of Enchantment is also the Land of Entrapment. It traps your imagination, in a good way. Somehow you wake up one day and your short-term lease, your short-term assignment, your short-term love affair has turned into indefinite-term, and you realize that despite yourself you can't leave.

You watch so many suns go down and moons appear, the river rising and falling, that it starts to become part of you, your soul's vocabulary, and if you ever leave something calls you back. You breathe with the land, you rain when it rains, you feel the dryness of it down to your bones. You wander among its trees. It's an alchemy of belonging.

I continue dropping moldy fruit pits into the holes. Evelyn kicks dirt over them. I ask her if any of the trees she's planted from seed have ever come up.

"Well, sometimes they do, sometimes they don't. But all I know is they won't grow in this skillet!"

THE MEMORY OF DIRT

"You know, honey, there is a spirit.
And the spirit doesn't wear out.
It's the body that wears out."

THERE'S A ROAD HERE IN CORRALES known as Entrada de las Animas, the gate of the souls, since if you stay on it you end up at the cemetery. People usually just call it Old Church Road because right across from the cemetery is the Old San Ysidro Church, which actually used to be the new church after a big flood washed away the old one

down by the river in the 1860s. After the flood, villagers, most of them farmers, built this church themselves with penny donations and their own muscle, adobe clay from near the river, and a few wooden beams from the destroyed church rescued downstream.

For almost one hundred years, Corraleños celebrated Mass here, got married, welcomed their young into the community, and had their funerals when it was time, burying the dead beneath the packed dirt floor. Light came in from the windows, heat from the sun's warmth was absorbed in the three-foot-thick adobe walls and radiated throughout. People brought their own little wooden benches every Sunday.

The church eventually became "The Old Church" and was deconsecrated in the 1960s when a bigger one was built nearby. Then it was nearly forgotten—at one point almost becoming a car repair garage and a place to store alfalfa. Then a community theater leased it for almost twenty-five years, staging productions within its adobe walls. Villagers acted in parts and made the sets. Beer and lemonade were served out of an old horse trailer during intermission. If you look closely above the door in the old sacristy, which served as the actors' green room, you can still make out the parting advice: "Act well your part; therein, all the honour lies."

Many villagers, including Evelyn's mother, mourned the loss and the deteriorating condition of their sacred space. They raised money and, with the help of the village, bought it in 1976. Volunteers then restored the church, brick by brick, board by board. Most any event we have here now in Corrales—art fairs, weddings, elections, holiday pageants—is held within this space.

The adobe walls here are alive—formed from earth, water, and sun by generations of villagers' hands. Every spring, right before San Ysidro Day honoring the patron saint of farming and of Corrales, folks add another layer of adobe plaster to the old structure. The women at the Historical Society cook red chile enchiladas and pecan pie. We scoop

trowels of cool mud set up with straw out of wheelbarrows and smooth it on top of last year's layer, adding our hands' work to all the hands before, to keep the old place standing for another year.

Right after San Ysidro Day, it's time to plant corn. Evelyn lines up the rows directly across from one another like square dancers. She does this to improve pollination but also to take advantage of what's underneath in the deeper layers. For years in this part of the vegetable patch, the boys have dumped apple scraps and skin left over from making cider. When something dies around the farm, it doesn't cease living; it merely yields life to something somewhere else. The soil in this spot is fattened on the sweet remains of old orchards. The corn will like it here.

Likewise in other parts of the garden. This year's rows of cucumbers and beans, sunflowers and cosmos will flourish on the land where the animal corral stood for twenty years. The remains changed the very composition of the soil, fortified by river water used to irrigate it. Anything left in the garden after the last frost will be tilled into the soil to support what will grow next spring. We're just adding another layer as we go along.

I like to wander inside the old church when it's empty. It feels good to be within its walls, surrounded by so many souls. The music played here sounds so pure, primal, like it's being drawn from a deep, cool well straight from the center of the earth.

Perhaps it's as simple as the physicality of the thick adobe walls and the design in the traditional form of a cross that allows sound to flow almost as if you can hear something else, like the whole place is quietly inhaling and exhaling, telling an old story in between.

I can hear the sounds of requiems and musicals, Santa's laugh, final words spoken at a funeral. Notes from an old pipe organ Fr. Phil played

for Evelyn and Johnnie when they got married; only half the keys worked. Layers of stories, the river itself. These walls still hold the three short rings of a church bell telling villagers a child had died. All the vows and applauses and tears held back, all the innocence and redemption of First Communion. They hold everything we want to hold on to and what will still be here when we're gone.

I returned home one day and noticed for the first time what I couldn't see anymore—the trails my dog once made while she was alive—little canine journeys to the edges of her territory where she liked to bark at people and horses coming down the road, to her favorite spots along the ditch, to the fence bordering the magic forest where she patrolled gallantly against coyotes and whatever else a dog sees that we don't. The trail along the road and all the way around to the other side of the house was the deepest still, for that was the route she sped through with pure abandon and glee when she'd see us pull up front. Years of this back and forth had transformed our land into a patchwork of green bordered by little worn pathways of brown.

The following spring, orchard grass had sprung up everywhere, filling in the old trails. A profoundly sad, uninterrupted field of green, swallowing her little pathways as if they never existed, as if she never existed. I was losing her.

The land remembers how it's been worked or neglected, it remembers the choreography improvised between the farmer and the seasons. The land on Evelyn's farm contains all the old seeds, the hard work, stories and friendships, ambitions and disappointments. It remembers all the late evenings of riding a tractor back and forth down its rows, all the times of running out of time, all its harvests.

When we live without this connection to whom and what came before us and that which will come after us, to the land we occupy, our food, the seasons, our neighbors and community—the whole constellation that we are a part of—we are confined to living in an isolated place. It can feel like trying to dive deep into too shallow water.

We live in more than just this moment.

When I brought our new dog home, she made her paths in the same old places. One life folds into another. Nothing, it would seem, is lost. Apples back into the earth to feed next year's hopes and plans. Our dreams and efforts connected with theirs. One layer of cool, wet adobe drying into another, until there is a wall, a place.

SUMMER

Susie in the orchard

IF THERE'S SQUASH BUGS
IN HEAVEN,
I AIN'T STAYING

*"I've killed plenty of squash bugs with my fingers,
and I do it with the utmost delight.
It's the best part of the day."*

I WOKE UP TO A BLOATED GOAT. I looked outside and saw that Caesar our pygmy goat was fat and grumpy and waddling around the barnyard. He had either eaten too much of a good thing or had discovered a bad thing. Gassy goats aren't really fun, and I hadn't even had a cup of coffee yet. I knew it could involve having to stick a turkey baster full of mineral oil down the goat's throat and somehow coaxing him into swallowing it. I wasn't sure what was supposed to happen after that. Of course, I gave Evelyn a call.

"Well, honey, you know how to fix that, don't you? All you have to do is get a sharp knife and jab it right in the stomach, just below the ribs. Mother used to do that, and we saved a great many cows."

Two hours later I wrote out the check for the vet, who was nice and very helpful. I just had to hold the bucket. Caesar was deflated and happy again. Off to the farm I went.

From July on at the farm it's fruit leather time. Early in the morning, Evelyn will put on a pot of fresh plums, apples, berries, and peaches. On through the day the ripe fruit simmers into a thick, gurgling syrup. Into the night it continues, slowly, bubbly. By the next morning, the fruit is as sweet as it's ever going to be. She spreads it onto trays and takes them outside, where they follow the sun and dry into sweet, chewy leather. Whenever someone stops by, she has them move the long tables of drying fruit a few feet this way or that out of the lengthening shadows, lifting the tables of fruit trays gently as if they were sleeping babies being moved into the warmth of the sun. By dusk, the tables are far away from the farmhouse.

July, too, is make-or-break time on the farm. Gifts and obligations equally abound. The squash is spread out as confident as new homesteaders. You're fat and stained from all the blackberries. The early summer crops are in— green beans, the snap peas, lettuces, arugula, beets. Sweet Italian peppers, chile, and promising tomatoes fill the rows. You carry your basil now not in palmfuls but in armfuls. You smell of countryside way into the evening.

The trash collector stops to admire a peach tree along the southern edge of the farm. "Those sure are some sexy peaches," he tells a blushing Miss Evelyn, who hurumphs back, "Fruit's not sexy, dammit!" To which he replies, "Well, that fruit is."

Everyone around the farm has been put to work, even Tony the tenant, who takes a dislike to most everything, including desserts, coffee, chile, and most vegetables. ("I grew them just to grow them, but I ain't eating them.") Tony lives in the converted chicken coop. I wonder if he knows that. I compliment him on his winter squash.

"Which one's that?" he spits out some tobacco. "Well, yah. Gardening sucks."

But I've seen him out there among the rows, working while pretending not to. He once buried Evelyn's dog who'd been hit by a car so she wouldn't have to. He cried the whole time.

If you can't get ahead of the weeds in July, don't bother. It's too late. The yellow mustard weed you neglected to cut back in early spring because it was so beautiful was also beautiful to viruses and bugs over-wintering. A healthy tomato plant that one day is all flush with fruit and green the next day has curled into itself.

Giggleweed, tumbleweed, pigweed. Bindweed, worst of all. It creeps up the blackberry bushes and strangles the corn. Its roots are twelve-feet long. It gets between your rows and won't let you through.

July means squash bugs, too. They arise from Middle Earth sometime in June and won't go under again until the snow falls. They are fearsome. They emit strong odors when squished. They can move forwards, backwards, downwards, and inwards. Evelyn's convinced they can hear when you're coming and take cover. At dawn they emerge and attack your squash plants from the undersides, sucking out their energy so by afternoon the plants lie withered like fallen prey. Nothing kills them—sprays, powders, traps, marigolds, stuff with warning labels on the side, planting late in the season, portable air-vacs. Not even Dr. Bonner's peppermint soap with Asian hot chillis. Dousing them in gasoline does seem to work; however, you have to catch them first.

Rows are abandoned now. Evelyn gets a call from a man who begs her to let him plant a row in her field back in spring. "Harvest what you can," he tells her. "I'm giving up."

Last winter, when my friend and I first planned our acre of potatoes, we met with some young farmers making a go of it. During lunch they disclosed how they normally weren't chubby; this was just their winter weight. By July, it would be all gone. They said, in fact: "You have to eat a stick of butter a day just to get through." They did not exaggerate. The stick-of-butter days have arrived.

Thinning the carrots, hoeing the chile, staking tomatoes, harvesting beans. Mound your potatoes and rebuild your berms. Up the ladder to pick your cherries. Down the ladder, unload. Next tree. Up the ladder and pick

your peaches. Down the ladder and hoe. Swing, dig, swipe, and pull. Blight. Wilt. Hail. Locusts. It's so hot. You're so tired. Eat your stick of butter.

Evelyn zooms past me on the neighbor's motorized buggy with a large, gangly plant in her outstretched hand, floppy yellow flowers and tiny baby zucchinis dangling from the ends. She reaches the pond, props herself up on the bank with her ski pole, and hurls the entire squash plant, roots, leaves, and all, into the middle of the water. "Drown, you little bastards!" Little grey bugs fly through the air into the water, like dazed and capsized cruise-ship passengers.

"And if there's squash bugs in heaven, I AIN'T STAYING!"

Evelyn was born on a rise in the land a hundred yards from here, among her grandparents' trees and vines, alongside the old acequia madre. She spent her infancy in a basket under a tree while her mother worked in a field that Evelyn still works today.

School could be tough. Her father bought her boxing gloves and told her, "I don't mean for you to come home the loser." Evelyn and her sister Dorothy had a lot to prove being girls. They worked twice as hard, but they could out-mow, out-plow, and generally out-work the village boys. Her father said he was glad to have girls.

Evelyn's family and most everyone around her were farmers. She understood later they were poor. She remembers during the Dust Bowl years how people from Oklahoma would pass through New Mexico on their way to bigger hopes in California. They would take any job for any amount of money. People called them the prune pickers. Evelyn will tell you one of the hardest things to see is people worse off than you, with barely anything to eat, taking your father's job.

Evelyn's family made their own pasta from wheat they grew and thrashed themselves, and they didn't brag about it. There were no refrigerators; her parents make-shifted a box along the north side of the farm to try

to keep meat cool. She remembers after one butchering, her parents ate the bony shoulder meat first and saved the cured ham part, the best part, for later. It spoiled by the time they got to it. Eat the best first, her father would say after that. It was a hard lesson to learn.

Certain images have never left her. The candyless Easter basket her mother improvised from a bent-up sieve holding a couple eggs decorated with homemade dye. Riding through the bosque in an autumn rain on her horse with just the sound of the river. Picking gunnysacks of mushrooms from the bases of the cottonwood trees.

During World War II, when her father was away much of the time working in the sawmills producing wood for the war effort, Evelyn, her sister Dorothy, and her mother held down the farm. The family didn't have a tractor until the late 1940s, so Evelyn spent her childhood behind Jumbo the mule plowing, mowing, leveling land.

Dulce and her girls had a way of getting the hay from the field to the farm and sometimes into town. She and Evelyn would throw the hay onto the wagon, where Dorothy would balance herself and stomp it all down. If they packed it right, they could make it all the way home. If they didn't, or if the wagon went over a culvert, all the hay would fall out, and they'd have to load it up all over again.

Growing up working for your food makes one bold, or at least able to look at the world squarely and not walk away.

At fourteen, Evelyn was sometimes in charge of irrigating the whole farm herself while her father was out of town working. She would walk the ditches barefoot rooting out gopher holes. She'd have to quickly fill them in so the water wouldn't rush out and flood the neighbors. She built dams and diverted water where it needed to go.

"It was a lot of work. Killing work," Evelyn says. "You had to stay with it."

There wasn't time for any of this to scare her. There wasn't a choice whether to stay with it or not.

Dorothy and I waiting for the school bus To
Bernalillo on Corrales Road. Dorothy has
her saxaphone

Queenie the goose

Growing the famed New Mexican hot chile pepper is equal parts art, science, and fate. People swear by magical dates on which they plant. March 21 seems to be a particularly providential date. They say to plant it deep if you want it hot and to avoid spring frosts. Gus Wagner down the road will tell you only to water your chile every couple of weeks. Get too much rain and it'll never turn hot. Even if it starts looking wilty, don't give in. The stress makes the roots go deeper, and the chile gets hotter. And you better have been brave and thinned all the starts when they first shot up. Sacrifice the weak and the strong will survive. You have to be ruthless.

Evelyn sends me to the barn to sharpen our hoes before we set out for the chile patch. Before Evelyn it never occurred to me that you had to sharpen your hoe. I would just chop harder or give up and try a shovel. But Evelyn likes a glistening blade.

"Your hoe's not sharp." She doesn't mince her words and points to the barn. There I fire up the sharpener, a madly spinning wheel that sounds like you're sawing through a limb. Sparks fly everywhere. It really seems like you could set fire to the barn this way. It doesn't help that it's dark in there and I'm wearing sunglasses since I'm fairly sure looking directly at the sparks is like viewing mini solar eclipses that can cause permanent eye damage. I do the job half-heartedly and at the wrong angle, so when Evelyn inspects it, she takes me and the hoe back to the barn, fires up the machine, pedal to the metal, sparks flying, sunglassless, hoe screaming, until the edge gleams with sharpness. Able to julienne most weeds.

By July, our chile is halfway through its growing season. It needs the soil loosened so it can drink and breathe. We work side by side. Evelyn scoots along the ground as she works, leaning on her left side as she has for years, freeing up her right side to work. Her body has memorized that curvature, like a line of trees bent over in the wind. She's been carved by the weeds. Dulcelina was the same. She'd be bent over all morning working in the fields. It would hurt too much to try and straighten out, so bent over she'd stay the rest of the day.

The calluses, the lines, the crooks, limps, and dips. What is that pain in one's back at the end of the hoe? Is that the creaking of the world's weight that I feel? The farmer shapes the land, the land shapes the farmer. Things not seen since we've left the land.

At times, when you're working in a field with someone else, there's a certain kind of quiet unlike anywhere else. You forget you're not alone. You can learn a lot during those times if you're listening. You pause every now and then and straighten from your work, watch the weather moving in, or perhaps no weather moving in. You start to see how it's all connected. And in that moment, while you two are leaning on your shovels, it is.

When you do talk, it's in more of a shorthand. Time passes, and you're not sure if you've been actually talking out loud or if it's all just played out in your head. I'll ask, "And what about those cucumbers, Evelyn?"

"No, honey, it's all okay."

Then moments later she'll finish out loud whatever thought has been quietly kicking around in her mind: "Don't water during the heat of the day. Plants don't like to have cold, wet feet and a hot head, my mother used to say."

"Okay, Evelyn." I will try to remember.

The chile looks more than a bit wilty, so I ask for her assurance. "The monsoons will start any day now, won't they?" I ask.

"Don't know, honey."

"Well, if they don't does that mean they'll have to cut off the ditch water next month, because then what do we do to water all this?"

"Don't know, honey."

"Well, they can't do that. We'd lose it all."

"Honey, we don't have any control over that. Either they do or they don't."

She picks up her hoe and resumes her work. "We'll just try, honey, and that's all we can do."

I remember how one day earlier in the summer part of the bosque burst into flames. It spread quickly, filling the valley with smoke. I didn't know what to do, and I couldn't do anything to stop it. "Honey, I know, I know," Evelyn said back to me. "It breaks my heart, too." And back she went to pitting her apricots.

Evelyn knows something I haven't learned yet. We are owed nothing.

Hours had passed. It was almost the end of day. We had done a lot, but I wasn't sure how we would beat the weeds and get all this done.

With the end of her row in sight, Evelyn scooted along to the next plant and took a long sip of water. She had found her second wind.

She looked back at all she had done. *"Ya mero!"* she exclaimed, out loud. Already, almost done.

LUNCHTIME

"We may be poor, but we sure eat well, don't we?"

IT'S MONDAY, A FARMER'S SORT-OF DAY off around here. Everything was sold yesterday at the market. There's nothing to sort or clean now. It's time for down-time. It's time to take lunch.

When I arrive at the farmhouse, I find Evelyn in her Lazy Boy watching a Dr. Seuss cartoon.

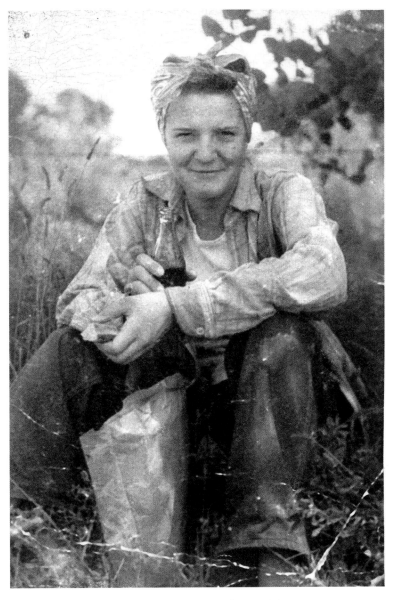

Me as a teenager taking five in
The fields.

"Well I didn't get to watch these as a kid so I'm damn sure not gonna miss seeing them now."

When the program wraps up, we head to the porch, the slow morning pace set by the Gabriel Fauré requiem drifting out from the kitchen radio. Evelyn closes her eyes and has Jen and I make a promise.

"Honeys, if there's any money left over when I die I want you all to hire a choir to sing a requiem for me somewhere, maybe in the Old Church." It used to be that requiems were routinely performed at Catholic Masses for the dead. In recent years, though, the custom seems to have fallen out of favor, perhaps considered too unnecessary, too much going-to-the-trouble. In any case we promise.

Evelyn can't not work so she starts folding newspaper into makeshift hats to protect the delicate tomato starts from the June desert sun.

Strains of *Carmen* have now taken over the airwaves. "I used to sing like that," Evelyn says to no one in particular. Gathering up a hoe, and leaning on it for her third leg, she heads out to the garden to check the tomatoes.

"And if I don't sing like that in heaven, I ain't staying."

Evelyn breaks into her own song as she walks, her voice rising and cracking through the morning air with the refrain from an old Italian tune about little shepherdesses singing in their field. Her morning anthem quickly segues into a loud "OH SHIT! OH SHIT! OH SHIT!" when I call out from the kitchen that the big pot of cherries on the stove has bubbled over, covering the counters and the floor with a steaming, gloppy mess of red.

Around the farm, lunchtime is a guarded ritual. It might just be an odd collection of leftovers. Sometimes it's just been pulled from the earth or taken from a tree without much else happening to it before it ends up on our plates. But lunch is never just gulped down drive-thru style while doing something else. It's always taken, but never for granted.

With summer's arrival to the valley, the season's first *quelites* appears—"Corrales spinach," as it's also known around here, lamb's quarters or goosefoot in other parts of the country. It grows wild in between cultivated rows and along ditch banks. It can easily be passed over as a clump of weeds, but as Evelyn will tell you, quelites kept Corraleños alive during the lean years.

Into a pot of water go the quelites, a little dirt and all. Half a minute, salt and pepper, maybe a splash of lemon juice. Out come pumpkin gnocchi made from an heirloom squash last autumn, doused in fresh sage butter and topped with slivers of Parmesan.

Evelyn disappears into the pantry and returns with a gallon of her apple cider. We pull out some homemade cheese, fry a few new potatoes with bacon, and break out leftover pie made with rhubarb from a neighbor's garden. Lunch was starting to take shape.

"Let's get out the silver and the good dishes, honey."

You can't take it to the grave, she'll remind you, so you might as well use it. As with many folks of her generation, her good silverware didn't just appear all at once from a gift registry, nor was it ordered on an impulse cruising the Internet. It came piece after hard-earned piece. She started saving money for her silver at fifteen when her mother had her gather and sell plums from their trees. I wondered how many plums-worth of silver were on the table today.

We clear off the farm table outside as the parade of early summer food makes its way to the table.

After the third bite, Evelyn announces, "We should say grace."

A flutter of forks hit the table as we nod in agreement. Evelyn says the prayer, capping it off with her own addendum: "And San Ysidro, bless our garden, make it grow, or else we'll stash you behind the altar; and St. Francis, help us to find all those squash bugs; and St. Jude, help us…" I miss what St. Jude is being implored to do because I am still trying to picture Evelyn stashing the statue of poor San Ysidro behind

the altar. Apparently, the story goes, farmers would banish their patron saint's statues when things weren't going so well in the fields. Old San Ysidros missing for years have turned up in the backs of closets, in garages, behind boxes.

We're gathered under the pecan tree in the same spot as Evelyn's cow pen years ago. She has a particular soft spot for cows. Her job as a child every morning before school was to milk Bossy, the giant Holstein who didn't like to be milked. She'd swish her tail in Evelyn's face until Evelyn finally tied it to the cow's legs. Then she'd lift her hoof and dance about and stick it right into the bucket of milk, usually spilling it. Back and forth things went like this until Evelyn and her family left the farm for a few months when her father had a sawmill project. They sold Bossy to a farmer in a village some twenty miles up the road. When they returned to the farm, there was Bossy, out in the fields. She apparently had left the farmer, crossed the river, and made her way back home.

Other stories flow, about the goat who wandered into the house to watch TV, and Bitch the bull who used to push down fences if you made him mad and let all the other cows free to wander around the village. Then there was the pig with short legs who thought he was a herd dog. We scoop warm cherry jam straight from the pot.

Sometime later we determine we are full now and content. We lean back in our chairs, healed by our midday ritual. The tomatoes peek out from the garden underneath their little newspaper sun hats. They look content, too. The rows of chile that needed hoeing aren't nearly as long as they had been before lunch.

SECRETS OF A FABULOUS PIE CRUST, AND OTHER LIFE MYSTERIES REVEALED

*"You can't make yourself sing, honey.
You have to let yourself sing."*

EVELYN IS KNOWN IN THESE PARTS for many things—her contributions as a farmer, music teacher, community leader, and on occasion hell-raiser. But let's face it, she can whip up a mean pie without cheating on the crust part. And that can get you through a lot in life.

When someone bid $400 for one of her pies at the Corrales Main Street auction, I knew it was time. Secrets had to be divulged.

It's that darkest time between the middle of the night and not yet dawn. The kitchen light reaches just to the edge of the kitchen, beyond which still belongs to the night. The coffee's hot and fresh. Evelyn is awake. Off the kitchen counter with a sweep of her hand go trays of fruit leather, half-written letters to the Village Council, a stash of tomatoes she refuses to sell. Out comes the Crisco, fruit, sugar, flour, some cinnamon, a little of her secret ingredient.

The pie making process actually started a couple days before and well into Saturday night as Evelyn cut up the fruit. She estimates she's peeled more apples than anyone. "Well, at least in the U.S.," she clari-

fies. Her work goes back even further, back to the vine, back to spring, back to when the fruit was not even fruit yet. This is the life of a farmer.

She starts by greasing the four huge pans she's greased every Saturday night/Sunday morning for years along with several individual-sized aluminum tins, then her collection of large glass pie rounds for her customers expecting Sunday guests. She toes around sleeping dogs stretching every so often into cooler spots on the floor. The radio fills the kitchen with *Tosca*.

For the past couple years, ever since Evelyn lost some strength to arthritis, her son Vince has risen early Sunday morning to help with the pies. He's the son who once planted an entire vegetable garden so Evelyn would have something to look out at while recovering from surgery. He measures flour by the pound in between sips of coffee. She makes the dough, he rolls it out. She prepares the fruit, he pours the filling.

Evelyn didn't start out as a baker. She started out as a farmer with a lot of fruit, a lot of different kinds of fruit. This is something that makes an Evelyn pie an Evelyn Pie—there is never just one kind of fruit underneath that crust. In Evelyn's math and religion, single-fruit pies are wrong, immoral. Put it all in. Pie, in fact, is a great way to clean out the refrigerator. I once saw her empty cartons of evaporated milk, condensed milk, coconut milk, and sour cream into a pumpkin pie crust—topping it all off with some homemade 180-proof.

"Now that's what pies are for," she instructed. "Food's food."

Evelyn is not keen on measuring, at least not with a tool. Instead, she goes by gut and the cup of her hand. She likes the addition of experiment and experience. A few handfuls of flour here, some baking powder there, a fresh goose egg, why not.

"Well, you have to do things proportionate, you know, with each other. But do you want the amounts? Do you really need that? Because I don't really measure. Well, honey, it's just that I kinda know after all these years. Well, okay. Here's how you make one farmers' market's-worth of pie. Take 15 cups of flour. With that much flour, add *at least* a tablespoon of

baking powder and 1 teaspoon of baking soda. I hope that's right. I usually…
hmmm. Let me think. Well, say a tablespoon FULL-FULL, how's that? Of the
baking powder. Okay? And a half-teaspoon of salt. Maybe. And cinnamon.
A little bit, I guess a half-teaspoon. Half a cup of sugar. Or something like
that. Honey, I do it by the feel, I don't know. So I would say with that much
flour, I guess 2 cups or so of Crisco. There's no need for butter, honey. Oh,
and about 10 eggs, I guess. Or if the geese are laying, then I'd cut that down
by 1 or 2 eggs or so and use the goose eggs. But then it's gonna depend on
the size. Of the eggs I mean. Okay, where was I? I'm coming, honey. Okay,
either milk or ice water. If your milk's gone sour, then you need to use more
baking soda. Mix the eggs and the water and then add about 2 tablespoons
vinegar, or maybe a quarter-cup of vinegar. You'll know. And that's it, honey.
I think I have everything in it.

"Oh, did I forget to tell you to add the cinnamon? Or nutmeg. I'm
not that fond of nutmeg with many fruits, though, as you know. Smear
a little egg white on the bottom crust, you'll see why. And I'm not tell-
ing the secret ingredient."

Well, then. Easy as pie!

Evelyn likes to teach her young music students a technique she promises
will keep them out of trouble, at least musically. All you have to know
is five notes. "You just chisel away on those, honeys, and if you have
the creative element you can play a lot." Good stuff, too, like "Amaz-
ing Grace" and "Ode to Joy." In fact much of the world's folk music is
based on these five notes—the pentatonic scale—since by leaving out
those two other notes, the trouble-makers as Evelyn calls them, things
always seem to harmonize and sound good together.

The same can be said for Evelyn's approach in the kitchen. Have
a few basics under your belt and then just chisel away. It will all taste
good in the end. She strings her notes together in her own style, chang-
ing it up with season and circumstance. She knows it like an old story.

Whipping something up by heart and a wooden spoon, it would seem, is a key skill in life, like knowing how to change a tire (or charm someone into doing it for you), transplant a rose, sing a lullaby by heart.

When first light peeks over the top of the Sandias and down into the valley, it's time. The first set of pies is ready to come out of the oven. Evelyn measures out pieces into two- and three-dollar slices, then reaches for her steak knife from the Golden Corral that can cut through anything, neatly and nicely. "I told the waitress, 'I'm either going to pay for these or steal them. What will it be?'" They sold them to her, a dollar apiece. Best thing on the farm.

Into the oven goes the next round. Evelyn takes her coffee, turns on the TV to the Sunday Mass from Rome, and rests in her favorite easy chair until market time.

I'm not too proud to rule out those perfectly coiffed, perfectly proportioned pie crusts from the frozen food aisle, but Evelyn has let me in on another little secret in how she moves in the kitchen and out into the world. Real beauty—sustainable and sustaining beauty—flourishes in the land of imperfection. This is the place where the seams are allowed to show. It's drawn outside the lines; it stays up all night and doesn't worry about what it looks like in the morning. It's too much baking soda and not enough sugar. It's being okay with just what you have.

Letting go of perfection is letting yourself sing. And it's letting yourself make your own pie, and sit down afterwards for a huge, happy slice.

TO MARKET, TO MARKET

"I think I made them mad.
But they don't buy my beans, so I don't care."

THE SUN ISN'T YET OVER THE MOUNTAINS this morning, but Evelyn is already out roaming the garden half-dressed in her undergarments and apron. Every Sunday morning during the growing season for more than thirty years, Evelyn has risen way before dawn to bake pies, polish apples, and sort bumpy cucumbers from the slicer cucumbers. Rain or shine, snow or hail, epic spring winds and come what may, Evelyn and the other farmers and growers in Corrales show up for market and hope the customers will, too.

"I have naked ladies in the garden, and I almost forgot!" She disappears into the shrubbery wielding a paring knife, Goldie tailing behind at her feet, yipping for ham. Vincent darts past, two more dogs all dots and stripes loping behind him, as he heads out to collect baskets of quelites from around the pond. Two farm pickups, a Jeep and a Mercury, are being loaded outside the barn with the goods: tables and tents shoved in between trays of peaches and beets, a dozen types of jam, plum vinegar, goose eggs, tomatoes, heirloom pecans, and anything else that grew or was concocted this week on the farm.

Evelyn reemerges from behind the clothesline with a handful of leafless and curvaceous lily-like flowers. She's pretty sure she's the only one in Corrales with naked ladies, having brought starter bulbs back from El Paso. She fills her jars with cool water and improvises little purple and pink symphonies.

A few grandchildren and an in-law scoop up the last baskets of carrots and okra before Joneve declares, "It's time," and the whole operation caravans down Corrales Road to Sunday market. Evelyn stays behind with the pies, scratching out labels on the back of an old envelope: "$2 a slice. Health Plus." I ask her what exactly Health Plus means.

"Propaganda, honey."

The farmers' market—now called the growers' market—wasn't always around. It didn't have to be. Trucks passing through Corrales used to pick up local produce to sell elsewhere. But then the trucks stopped coming sometime in the 1970s. It was a combination of new regulations and supermarkets springing up in town offering produce shipped from elsewhere available 24 hours a day. People didn't need to drive out to the country to buy produce from the farmers.

Corrales farmers were left with a lot of chile and apples on their hands. That's when Evelyn's mother and a few others started the first farmers' market down in Albuquerque. Evelyn would rise at 2:00 in the morning to sort and clean produce to make it to the market by 6:00 a.m. There she'd work several hours selling produce before driving all the way home again, hot and sleepy, in the rickety old farm Chevy, singing to keep herself awake.

One such sleepy afternoon back in the early 1990s, during the final stretch of coming home, she thought: We need to keep Corrales rural. Why don't we have our own market? Evelyn, Ursula Weule, and Elsie Kinkle patched together a plan and a petition, some of Ursula's infamous pickles and Elsie's blackberry pies, and started the Corrales growers' market. Russell soon came with onions, Rudy Perea with peaches, the Findleys with raspberries.

The Corrales market has expanded many fold from those early days to scores of vendors, with more joining every season. Every Sunday morning they line up behind their produce with hot coffee, waiting for Al the market manager to blow the 9:00 a.m. whistle that opens the proceedings.

Golden Delicious on the way to market

Evelyn is in her element at the market. She's proud of what has come from her farm, and she wants to share it. Regulars and newcomers stream past her tables of pies, jams, and produce.

First in line this Sunday is Mr. Roth, who must be in his eighties at least, with a blue newsboy cap perched on his head. He can be seen swerving around the village on his rickety Schwinn balancing a week's supply of Evelyn's pie or a stack of free-for-the-taking books from the library. If you happen to be driving behind him on Corrales Road— "Ohhhh, be careful, Mr. Roth!" —you have to make a wide berth around him.

Evelyn talks with a customer about Charles Darwin while simultaneously lecturing another about wasting drinking water on growing wine grapes. "Oh, hi, honey," she says, her arms melting around a young girl who comes up to give her a hug and a basketful of fresh eggs—another unofficial "grandchild" of Evelyn's. She refuses to sell a man beets because he wasn't going to use the greens.

"I worked too damn hard growing these!"

Anthony from Wagner's Farm sends over big glasses of fresh watermelon juice; Evelyn sends him over some warm pie, all part of the underground exchange that happens between folks at the market. If you don't grow or raise it, chances are your neighbor does, and you probably have something he needs, too: a bag of beans for a dozen ears of corn; bottles of Peach's treasured Garlic Oil for a basket of new potatoes; chile for freshly baked Pueblo Indian *horno* bread.

Bartering is in the farmer's blood since cash isn't always in the pocket. Evelyn's living room is filled with handmade weavings and other crafts traded for crates of fresh apples with neighboring Navajo and Pueblo Indians. Back in what Evelyn calls her peddling years, aunts and uncles on the Curtis-Losack Farm would load the old truck down with apples by the bushel. Evelyn would head out in the middle of the night to the Indian reservations with her Auntie Lena, who apparently couldn't see all that well, a condition Evelyn wasn't aware of until she figured out that Auntie would

drive down the center line of the road so she could make out where she was going, moving over just in time when she'd spot headlights coming at them. That's when Evelyn learned the hard way about packaging, too. If she didn't put the red apples in the white bags or the yellow apples in red bags, the Indians simply wouldn't buy them. She never knew why.

One time Auntie Lena talked Evelyn into heading over to the Zuni Reservation for the Shalako ceremony. They were already tired from having spent the day selling apples in Gallup. Waiting outside the ceremony, which went on well into the night, the two fell asleep in their truck, cold and wedged between crates of apples. At some point the Zunis invited them in to watch the dances, pray with them, and partake of stew and traditional bread. Auntie Lena assured Evelyn that as soon as the ceremony ended surely everyone would come out and buy all the apples and they could head home. But the dancing and praying went on until daybreak, then broke and the Zunis dispersed. Evelyn and Auntie Lena returned to the farm with just about as many apples as when they left.

The Squash Blossom Boys have arrived at market this morning and are soon plucking out tunes on fiddles and guitars. The after-church crowd arrives and mingles with people in bike shorts and helmets trying to figure how to cram winter squash in their backpacks. The mayor and his long-eared dog make their rounds. Someone passes by with a big jar of Evelyn's naked ladies and a French loaf. A couple puts down their baskets and start dancing.

Evelyn slips some free cucumbers to an elderly woman who lives alone, and to another woman buying with welfare stamps she gives a bunch of "tacky" peaches, good and sweet but a little beat up. "Here, honey, you just take them." A man who might be drunk says, "Happy dreams to you," and she extends the same wish back to him and gives him some eggs to take home so he doesn't go hungry.

Aura Woman shows up and makes her way carefully and methodically around the various booths in the market. She lets her hands hover over produce, careful to make wide arcs around certain booths whose produce doesn't pass the positive energy test. Evelyn's booth seems to pass muster. I once saw her place her hands over a basket of quelites collected from the farm, pause for a moment, open her eyes, and declare to Joneve, "I want all of these."

We wonder what's happened to another market regular, the Fairy Godmother, a happy woman in her late middle age who always dressed as a fairy because apparently she believed she was a real-life fairy and carried around a wand, which is only a little weird for Corrales. Evelyn didn't mind; she was a good customer.

I stop over to buy some garlic from Russell. This week he has a big bowl of oyster mushrooms he gathered in the bosque along the river, the way folks used to do before they appeared in squeaky Styrofoam containers next to the prepackaged egg rolls. Mushrooms like to grow at the bases of old cottonwoods or along their roots. Russell says they grow so fast he's been tempted to sit up and just watch to actually see them growing. His test to determine if a mushroom is edible or poisonous? "Just put it on your tongue, real quick-like, and if it doesn't burn, it's okay."

Here, the growers stand behind trays of sun-ripened peaches, bunches of fat radishes, rainbow-colored carrots, wild quelites just pulled from the acequias, new potatoes still raw and real with earth, sweet jars of wild plum, and things not tasted since childhood. Pecans gathered like seashells, vegetables and fruit all picked by hand as soon as they are done growing. Here, the most intimate cycle of sustenance, of life, is completed.

Noon comes and the market winds down. Evelyn's kids shoo her home to rest. The tents are taken down and packed for next week, our leftover green beans swapped for leftover zucchini with the growers next to us. Tomorrow will be another day on the farm. And if we're lucky the first of the apples should be ready, just in time for next week's market.

KITCHEN COUNTER

"It takes a lot of work to be eccentric.
Everyone's always trying to change you."

FOR A COUPLE HOURS EVERY OTHER TUESDAY for more than forty years, my grandmother would get together with a group of her friends and play bridge. When it was her turn to host, Nana would take out the good china and crystal and have me dust the bottoms of the living room furniture the day before. She'd whip up some pink squirrels for the girls and take out the good card set, the crisp, slick ones with the aqua-marine tinted race horses on the back that we never got to play with otherwise.

I didn't realize until much later that those gatherings had very little to do with cards or good china, or even with pink squirrels (although those surely didn't hurt matters). Passing time together was simply a necessary ritual in these women's lives.

Which is what people seem to do an awful lot of at Evelyn's farm. Despite much that needs to be done in field and orchard this day, Evelyn is perched atop her favorite stool at the end of the kitchen counter, holding court with whoever happens by. The back porch door is almost always literally open—and no one really knocks—regardless of the season, and if it isn't, Evelyn is most likely in the kitchen motioning for you to come on in.

"The cucumbers can wait today, honey," Evelyn calls out as she resumes telling a story about the time she visited the Holy Land years ago. She somehow ended up on a tour bus of born-again Christians

being taken around by a Jewish guide. When the born-agains kept asking their guide whether he had found the Lord Jesus Christ, he just went silent and wouldn't respond. It was a long bus ride.

Mary Davis has joined the group around the counter. She likes to stop by occasionally to look at Evelyn's closetful of old photographs. Evelyn slides a picture down the counter to her. "Look at this one. It's Mother, skinning a pig."

In the other room, one of Evelyn's music students is finishing up some scales on the piano. "Come take a break, honey, and have a little something to eat." Michelle from down the road appears at the door to stock up on apple cider for a party; she has time for a cup of coffee, too.

The kitchen counter is where Evelyn's world begins. It's from here that petitions are drafted, letters to the editor fired off, pie dough rolled, advice given and received, jams sampled, meals concocted, family celebrated and consoled, bread broken, gossip dispensed. The kitchen counter is the altar that celebrates the simple but seemingly lost ritual of just dropping by. Here, life is allowed to be just as it is; no preparation, no menu, no crystal candy dishes, no agenda. It's a place of beautiful and vital inconsequence.

We're on the second round of coffee when the Mormons show up. Elder Gibb and Elder McFarrell, who don't seem to be quite elder enough to have started shaving, want to see if they can help on the farm. They already know: she's not converting. Catholic to the grave and beyond. They changed into their work clothes all the same, and Evelyn sends them out to the cucumbers. A few years back some of the young Mormons away from home stumbled upon Evelyn's doorstep after a particularly bad day of being yelled at and having the door slammed in their faces. She felt so bad she invited them in and started playing the piano. Everyone sang along. Since then, the Curtis-Losack Farm is on the Mormon-on-a-Mission map. God and Jesus aside, Evelyn's taught them about parsnips, made them sample fresh horseradish just so they know what it tastes like even if they don't like it, and taught

them how to squish squash bugs. "We don't even know what to do with them, but she just comes out and cusses at them and squishes them in her fingers," Elder Gibb says, a bit stunned.

Evelyn is one of the most generous persons you will ever know. If she's not feeding you, she's giving you something she's grown or found. She gives music lessons for free when times are hard; she'll give you work, flower starts, a place to go on holidays so you're never alone. Her truck, take it. Her shoes, well if you need them that badly. A place to stay. A spot at her kitchen counter, even if the furniture legs are a bit dusty. Her time.

The sun's at its hottest when Evelyn calls the Mormon boys in from the field for some cold water. They take their place at the counter and share some lunch with everyone before putting on their ties and name tags and heading back out into the world.

EVELYN'S SPICE GARDEN

THIS IS HOW EVELYN TELLS IT. "I had a nice little garden on the north side of the property, where I planted cilantro and basil. I found a little box of caraway in the cupboard, and I thought, Well, I'll just plant it! So these little plants came up. They looked beautiful to me.

"But Mike came over and said, 'You're gonna get in trouble with those plants.' And I said, 'No I'm not, either. They're spice.'

"Well, anyway, he kept after me until finally they kept getting higher and higher and people could see them from the road. I had thirteen big plants! I really didn't know what I was going to do with all of them. Then I get a phone call, says, 'Miss Evelyn, people are seeing some plants of yours. You're gonna get carried away with that caraway.'

"Then one day Johnnie was clearing some weeds over there, and some men in suits came by and said, 'Whose garden is that?' And Johnnie said, 'It's my wife's spice garden.' And they said, 'It's spicy all right.' And they went on.

"So dangit, I called the police and they came, and they took some, took a sample, and they called back, and they said it wasn't—what do you call it—cannibal?—what's that?—cannabis. They tell me it's not cannabis. It is a spice, then they tell me, 'But Mrs. Losack, would you please not plant it next to the road next year?'

"Then one day I went out to irrigate, and someone had taken a bunch of them, roots and all! And I went out later, and more of them were gone. Someone had brought a shovel and dug them all out. Just helped themselves to it.

"Everyone had a good laugh at old Evelyn for that one. But I had just never seen a pot plant."

DARE I EAT A PEACH?

"Just let it go, honey. I wish I would have spent more time to have fun with my kids, but I just had too much to do. I shoulda just let the damn dirty windows go."

EVELYN WAS IN ONE OF HER USUAL spots this hot July afternoon, perched on a bucket outside the kitchen door, culling fruit—the big peaches in one box, mediums and smalls in the other. No one wants to buy the peaches that are slightly bruised or marked, so Evelyn sets those aside as giveaways to friends, including a bag for her doctor.

"They're still good peaches, but he's gonna have to deal with the bug and bird parts." The really-not-so-prettys are bucketed for making jam.

We had spent the morning reaching high into the trees, then trolling about on our hands and knees, searching for fallen wild plums, wine-stained, like trying to gather all the jewels from a broken necklace flung across the dance floor the night before.

I know better than to pocket some of the peaches for a pie. She believes a ripe peach is perfect just as it is and should be eaten straight away, not covered up with flour, sugar, and butter. Her exception is adding ripe peaches to Cheerios, as we did this morning, hunching over big bowls of it, cutting sun-warmed slivers into cold, whole milk as we went along, not talking, it was that good.

A piece of fruit is the simplest, most complicated thing in Eden, on this earth. In it is the world. It needs nothing else, for it's all already there, like a pat of butter, or a wink, or catching the moon in the middle of the night and falling back to sleep.

Evelyn picks out a peach from her basket. "Try this," she says. Still butter cream-warm from the orchard, it fills the palm of my hand. I taste the sun.

I hand it back to her to share, but Evelyn just says, "No, honey. You finish it. You might never have another this good again."

We pack up the last of the fruits and head out for the Wednesday afternoon market. On the drive, dirty, happy, crazy-tired, summer still in my mouth. Off to the right we pass the Gonzales field that has only ever been a field and will stay a field forever. The sunflowers from Evelyn's seeds that the village schoolchildren planted there in the spring have finally opened up and are chasing the sun.

CALL THE POLICE, EVELYN'S MAKING PICKLES

"Never put lime Kool-aid in anything because it will turn
whatever you have green. I had a mishap
with that one time, honey."

EVELYN IS IN HER GARDEN, waving a large knife and calling me over.

"Honey! Come see. We have southern France out in back."

There, among the discarded peach pits and roses, was an emerging spread of capsized pale mushrooms that hadn't been there the day before—not just the white, ubiquitous kind that springs up after a rain but something a bit odd and different.

"What are those things called in France you pay $300 a pound for? Truffles?" Evelyn lops off a few heads and charges inside. "C'mon, we have some research to do and pickles to make."

Late August days around the farm are measured not in length, which is long, but in trays and tonnage of cucumbers. Jen and I spend the morning picking them, but by afternoon, more have arrived.

"You missed some," Tony says, inspecting the rows.

If you put off harvesting your cucumbers for too long, they turn bitter and indignant and no one wants them. Get them young while they're sweet and still fit into jars.

Today it seems the cucumbers have taken over the farm. Rows of them are squeezed between trays of peaches in the cold room. They overflow from baskets under the cool shade of the pecan tree, cover the kitchen counter, are stacked up under the dining room table. This morning's pick rests on the coffee table under a copy of Evelyn's latest dollar-store find, "It's Never Too Late to Love a Computer."

It's a scene that hasn't changed much around here in fifty years. Evelyn's parents planted patches of cucumbers in between the fruit trees to give them something to do until the fruit came in. Dulce would sell pickles a dollar a piece at the growers' market until "the environmentalists"—Evelyn's ironic, catch-all term for anyone in charge with too many regulations and little street smarts—moved in. They banned the sale of pickles unless they were processed in a sterilized, stainless-steel commercial kitchen. (They even banned Ursula's popular pickled garlic, and that really broke her heart.) Pickles went from a market favorite to illegal contraband.

But Evelyn is not swayed easily. It's state fair time and she intends to win. Besides several pickle categories, people compete for the Largest Turnip, Best Lug of Plums, Best Warted Gourd (large or small), Best Pinto Beans, Best Fancy Packed Food, Best Chow Chow Relish. Judges are discriminating. They see if the fruit preserves are soft and the syrup a good, bright color; if small pieces of fruit are suspended just right in the marmalade; if the apples have market appeal and the chiles in the ristra are uniform. Does the jelly quiver?

The fair is a rite of late summer. Farmers and growers can pause and celebrate their hard work, can stop and say, "Look at what I grew all summer long." But for Evelyn it's all about the first, second, third, and best-of-show rosettes. Days leading up to the fair are filled with scouring the farm to gather the finest ears of Uncle Gilio's blue corn and tracking down any quince that can be found in the orchard. I tag behind Evelyn as she treads through old stands of grapes, hunting out the

enchanting little petit noir and the sweet mission grapes she says were handed down directly from cuttings the Spanish missionaries brought with them centuries ago. ("Honey, how am I supposed to know that for sure? But it makes for a good story.")

For years the Salces, Curtises, and Losacks have competed with one another to see who could out-do who. Auntie Ida even went so far as to tell everyone in the family not to bother entering the Best Fruit Basket competition since she had won it twenty-five years in a row—until Evelyn came up and won it one year, shocking and pleasing the whole other half of the family. She counts that as one of the proudest moments of her life.

Since early August we've been making various batches of pickles for the fair. "Fast" ones, when we don't want to mess with brines, and "slow" ones that sit, pickling, in crocks for weeks. We make dills with the sweet and tender small cucumbers and chop up the rest into bread-and-butters.

The mushrooms have side-tracked Evelyn for the moment as she pokes around the house trying to find a fungi identification book, combining that with a search for canning jars. She opens the dishwasher her kids bought her years ago and peers in. Evelyn has never washed a dish in it (uses too much water) but has discovered that it's a great place for storing the wide-mouths and their lids. She sends Jen and me out to the barn to find more jars.

"Be careful where you walk. Sometimes you can fall through the attic floor," Evelyn calls after us.

Homemade pickles are one of those visceral things that few bother to make anymore, especially the "slow" varieties, so when you stumble across the real thing they seduce you in such a way you really can't imagine living without them. Which explains what happened last week.

Word somehow got out that Evelyn was making pickles. One of the Corrales police officers whom Evelyn calls the "lady cop" apparently

caught wind of it. On Sunday she bee-lined toward Evelyn's booth at the market and cornered Evelyn's daughter Joneve.

"I hear your family is selling pickles," she said starchily.

"Pickles?" Joneve looked away, suddenly becoming very busy. "I don't know anything about any pickles." Joneve was worried. No one mentions anything about pickles at the growers' market. And now there's a cop poking around, asking about them.

Lady Cop softened a bit, leaned in toward Joneve, making sure no one else could hear her. "It's just that I grew up with my grandma's homemade pickles, and I just really miss them. It's been so long…"

Joneve whispered something back to her.

Everything came to a halt at the farm when Joneve pulled up after the market with the police following right behind her. Lady Cop got out of the car and went straight to the back porch where all the pickle jars were cooling. Evelyn demurred, "They're not even settled yet, Officer. It takes ten days." She waved a wad of cash toward Evelyn, picked out four jars, and stashed them in the trunk of the squad car. "I'll be back for more later," she called out the window as she drove off.

By the time we return from the barn, a little bruised but with armfuls of jars, Evelyn has the State Farm Insurance man behind the stove sampling spoonfuls, asking him if there's too much lime in the pear compote. Then the phone rings; it's Evelyn's retired opera-singer friend from the MET.

"Honey, you've traveled all over. You've been to France, haven't you?" she starts in, describing the mushrooms that are now strewn across the counter and covering the insurance papers.

The State Farm man looks worried, making Evelyn worried that he's worried that the compote's too limey. She scrawls out a new label for it: "Key Lime Pear Jam."

"There. That solves that problem!"

This is how jam is made around here. Evelyn doesn't follow a recipe, and if she does she often omits ingredients that don't suit her. Like pectin, for example. It's too expensive, so instead she lets the fruit cook all day to thicken it up. At times this means the jam is not actually "jam," so it becomes "fruit syrup," "butter," or "compote." Then there's the "Splenda Mess" she makes begrudgingly for Pauline, whose husband Mel is diabetic. Every year Pauline orders twenty-four jars of jam, two jars for each month, in travel sizes. Evelyn doesn't trust what she refers to as the fake sugar, but she makes it anyway. She can't imagine life for Mel without jam.

Evelyn detours to check on her crocks of vinegar brewing in the back room. I never stopped to consider where vinegar came from. I thought it was just one of those elemental things, like air or sulfur or the flag. Evelyn motions me over to take a look.

"Isn't she beautiful?" Evelyn is pointing to a large substance that resembles a lost jellyfish floating atop peach peelings and water.

"Wanna taste?" She hands me a spoonful of the mixture. I feign fullness.

Evelyn determines the vinegar needs more time, still a little too tart. The thing floating on top, the mother, requires a few more months-worth of fermenting. Afterwards, Evelyn will remove the mother and start a whole new batch, like sourdough starter. The family has continuously made vinegar like this for at least the past one hundred years.

Evelyn doesn't can just to can. Her main mission regarding fruit is that nothing ever gets wasted. According to Evelyn, if you're lucky enough to have fruit trees, you better be doing something with them. Canning your own stuff tastes better and has a lot less sugar and none of the gunk you get in the store-bought. It doesn't take gas to ship it across the country. And canning keeps you out of the casinos. Besides, she'll tell you, canning makes you tough. She's been doing it so long

she can pull processing jars straight out of the boiling water with her bare hands, a kitchen feat not unlike fire-walking.

Today we're making bread-and-butter pickles. Evelyn's pickle recipe cannot be duplicated, not even by Evelyn. It's all about experimentation, she'll remind you, and on most days she's just making it up as she goes along.

Evelyn sends Jen up the ladder to the highest cupboards, high above the rest of the kitchen, to find whatever spices she can. Half-jar of thyme: Throw it in. Cinnamon almost empty: let's not waste it. In go the left-over garlic cloves, the dried habaneros, some horseradish, the ginger. "Let's just put it all in, honeys, and cover up one flavor with another," Evelyn encourages from below. Pequeño peppers, garlic flower tops, dried mustard, brown sugar.

Evelyn's job during all this is to sit at the head of the counter and place the cucumbers into the jars. She's shoving, pushing, squeezing, and cussing them in, covering them up with grape leaves for comfort and a pinch of alum for life before they've had a chance to straighten out. "There, you little bastards!" On goes the lid.

By late in the day, all the trays of cucumbers scattered throughout the house have transformed into crocks and buckets pickling away in darkened corners. Evelyn has found time to phone the police station to invite Lady Cop to stop by the farm to lend a hand. The key-lime pears are now compoting in Ball jars that line the credenza and kitchen counter. Every once in awhile, there's a POP, then another POP, telling us they're sealed well for the wintertime.

In the back, cider is slowly becoming vinegar.

We never did figure out what the mushrooms were, but the woman from Marcos' Veterinary Clinic who does the flower arrangements for dead pets stopped by and convinced Evelyn not to eat them, at least for now.

We load up the farm truck with her entries for the fair. Evelyn climbs determinedly into the driver's seat. "Honey, I hope you don't mind my driving, but I need the practice." We both laugh.

"I can drive fine in the orchard, you know, it's just in the city that I worry about."

Evelyn knows everyone and vice versa at the fairgrounds. She's been entering the agricultural and home arts competitions since the 1940s when the county extension agent came through Corrales and encouraged the women to start a 4-H chapter. They were just emerging from the Depression, Evelyn recalls, and no one had anything, not even decent mattresses. Most were just stuffed with old corn husks. So Evelyn's mother, Mrs. Targhetta, and Mrs. Deboute got together and formed their own chapter, setting up shop in an abandoned house near the Alary farm. They'd get together at night and make new mattresses for everyone, or tear up old clothing into strips and hook them together to make rugs. Evelyn took a home beautification class and learned how to can produce and plant flowers. She's never stopped.

Eleanor, Pat, and Joan, the state fair volunteers who get assigned to register Evelyn's truckful of produce and jam, are having quite a time figuring out the categories for her entries. Her "Holiday Apple" can't be entered under "Holiday Apple" since there's no such category, and she's already entered something under "Conserve" so she can't call it that. Evelyn is nonplussed. She instructs them to simply call it "Other."

"But you've already entered too many items under 'Other,' Mrs. Losack," Eleanor protests.

She somehow gets them all entered only to discover there is no category for "York Imperial" apples. Poor Eleanor has to break the news. Evelyn marches off to track down the county extension agent.

"What should I do, cut down some of my trees because you don't have that category? People need to be educated—this is a perfect York, a maligned but perfect tree, dammit!"

The judges all compliment Evelyn that she's been here a full two hours before uttering a single cuss word. "You're doing great, Evelyn!"

Evelyn and the county extension agent go back and forth. "Why don't you have more categories?" Evelyn starts, adding "I'm going to write a letter all the way to the governor's office."

"If we had more Evelyn Losacks, we'd have more categories," the county extension agent retorts.

Then he offers up a compromise—he will put her York Imperial in a non-judged category and call it "Educational." That seems to appease Evelyn.

We lunch on plums and jam that couldn't fit into any of the categories and pack up our stuff, confident of sure winnings. Our day at the fair has ended. Evelyn lets me drive us home.

We take the long way, down a slow, straight road past fields and the river, the back of the truck now lighter with emptied apple carts. We roll the windows down, and the late summer air flows in. Evelyn starts in on a story about the time when she was young and her mother had all the 4-H members over to the house to make the rag rugs. The kids were left outside to play baseball and cool off with Dulce's cider which, unbeknownst to the adults, had gone a bit hard. Evelyn and her friends got so giggly and tipsy they soon couldn't hit the ball straight. Poor Dulce had to stall and entertain the others until the kids were straightened up enough to be sent home.

Evelyn laughs to herself, still back at the farmhouse seventy years ago. Her eyes flutter shut as she leans against the door, drifting off into one of those pleasant, gauzy passenger-seat naps all the way home, lost somewhere between then and now.

RHAPSODY IN BLUE

*"And I wouldn't mind if you had the bagpipes
played at my funeral."*

ONCE WHEN EVELYN WAS PUTTING TOGETHER a music program for her students' recital at the Old Church, a young virtuoso pianist in town for a performance asked if she could practice on Evelyn's piano since it was nearby and recently tuned. The girl showed up and played through the morning, four hours straight. But every once in a while she would stop playing altogether for several minutes and just sit soundlessly. Then she'd bang something out, followed again by a long pause. Evelyn was curious but didn't dare interrupt. What wonderful contemplation and concentration, she thought. At lunch, Evelyn just needed to know and asked the pianist what was going through her mind during those long pauses.

"Oh, I was texting."

This morning Evelyn's piano seems to her somehow broader, the keys deeper and more spread out than the day before. She sorted apples all day and night, and now her hands are stiff with arthritis and cooler weather approaching. She's concerned about the upcoming performance, worried her students may need her by their side for some of the tricky parts or at least to turn the pages. Evelyn's especially concerned for her students performing the big finale—a piano duet featuring Gershwin's wild and twisty "Rhapsody in Blue." Remarkably, she's talked Sayre, a forty-something village councilor who hasn't played the piano since she was a kid, into playing the second piano.

Sayre first met Evelyn when her seven-year-old daughter started lessons. When Sayre picked her up after the first lesson and asked how it went, her daughter looked bewildered. It seems that when all the students arrived at the farmhouse, Evelyn had announced, "Children, it's state fair time, and there's no time for music!" Instead, she sent them outside to gather produce.

Tomorrow they'll load one of Evelyn's pianos, beat up from years of little hands and big notes, into the back of the pickup and drive it slowly down to the Old Church for the recital. Until then, Evelyn won't leave the piano until she's prepared and satisfied.

Her son Vincent sits next to her on the piano bench. He takes over playing the right hand parts; Evelyn can handle the left. And together they play the "Rhapsody."

Music is always in the background at the farm; it melodies the landscape here. Evelyn's grandfather Angelo sang Italian operas while working, his deep tenor rising from half-cleared fields and tangly vineyards. Evelyn's mother and her sisters grew up believing this was how you worked and lived: life accompanied music. They sang their way through cutting hay and picking cucumbers in Spanish, Italian, English, whatever was in their minds that day. "Si a tu ventana llega una paloma, tratala con cariño, que es mi persona…If at your window arrives a dove, treat it with gentleness, for it's my soul," notes rising like blackbirds through the fruit trees.

This was the world Evelyn was born into, learning melodies before she could read. Her parents found a half-working piano for $55 and scraped together enough money to hire the stately Mrs. Daniel C. Kloss to give Evelyn weekly piano lessons. Evelyn's favorite times growing up were the days she spent climbing through her family's apple trees, singing her mother's O Sole Mios and Johnny Appleseeds while she picked apples.

Piano lesson

Sometimes, in the dead of night, Evelyn would lie awake in bed and hear fragments of long mournful prayer-songs drifting through the village. Someone had died. Women would gather around the body, laid out in the family's home. There they would chant through the night in Spanish the sacred melodies of the *velorios* to help deliver the spirit onward. Evelyn remembers when her Uncle Arthur died, her Grandpa Salce, her Grandpa Curtis. All through those nights, Bruna Sandoval and Rosaria Gutierrez led the spirits with song.

She remembers when the priest rode in on his horse to say Mass, which maybe only happened once a month or for funerals. Auntie Cathleen would head out into the fields, round up all the children, and take them to the church. There she'd pump up the organ in the back that was so old the bags leaked air, the children circled behind singing as loud as they could.

Evelyn assumed when she went away to college that she would study farming and the home arts, but she signed up for a music class and loved it, despite feeling she was terribly behind the other students. She didn't know the key signatures, didn't know much about harmony or theory or music history, lacked the formal music background the others had.

She persevered and before long enrolled in the music department to become a music teacher. She taught a few days a week in Corrales, then a couple days a week she'd drive off in one direction to teach in the mountains for a half-day, then drive the other direction during recess to teach at a different school in the afternoon, in all traveling five hundred miles in a week. She taught through her lunch hour.

Evelyn organized and directed operettas in four different communities in the span of just a year and arranged for the kids to put on recitals. She put together a musical pageant about Corrales, somehow convincing her friends and neighbors to give up their evenings for rehearsals. Sets were built in backyards, a high school auditorium borrowed, and

the production ran for several nights. On two occasions in two different states, Evelyn was chosen as teacher of the year. She was the teacher you never forgot about.

Back in the 1970s when Evelyn and her family lived in El Paso for their jobs, she would round up her kids on Fridays after she finished teaching and off to Elephant Butte Lake they'd go. Johnnie would fire up the motor boat and take the kids skiing. By the end of the day, they'd all turn to Evelyn and say, "Okay, Mom. Your turn."

Evelyn would get behind the boat and ski away, one leg way out behind the other, an arm waving into the air, all the while singing "Oh, What a Beautiful Morning." They got her trick skis so she could add a few stunts. She'd get upset if the boat would run out of gas and they had to stop. Dark didn't dissuade her, either. There was the full moon, after all. On she'd go, into the night, singing at the top of her voice. "There goes the opera singer on skis," people would say, her voice carrying across a good part of the lake. The park rangers mostly just turned their gaze and let the lady go on singing. The whole lake knew her.

These days, the students come to her. Afternoons around the farm there's a steady stream of children shuffling into Miss Evelyn's living room for their weekly lesson, loaded down with piano books and excuses as to why they didn't practice. One of her students, a little altar boy down at the church, has fallen in love with the piano. Evelyn is urging his grandmother, who is raising him, to get a keyboard. She promises to give him lessons for free if that's what it takes, but he really needs music, she tells the grandmother. Some of her favorite students are a couple of Mormon girls. Evelyn likes to trade lessons for chiropractic adjustments from their father, whom she credits with somewhat straightening her farm-bent back.

On certain Thursday nights in the summer, after spending all day in the fields, Evelyn gathers some of her students, trades her work apron for

pearls, and heads up the hill to Santa Fe for the opera. It's dress rehearsal night, so tickets are cheap, and her kids need to see their first opera.

In over sixty years of teaching, literally thousands of people have learned music from Evelyn. When she's out and about, she's always running into former students. One time she took an order of apples to a local co-op grocery. She made $160, which would normally be a good sale, but she was so pleased that she got distracted and accidently pulled out into oncoming traffic and hit a pickup. After the insurance deductible she walked away with the whole venture costing her $340. But like so many Evelyn stories this one had a surprise ending. The guy she hit turned out to be a former student. He convinced the police not to give her a ticket and ended up giving her a lift back to the farm. He brought his kids by later that day to buy apples.

It used to be that you could hear Evelyn singing opera from her fields all the way up to Manierre Lane on the north end of Corrales down to Mariquita Lane on the south. But a few years ago she got sick and landed in the hospital for weeks. The experience damaged her vocal cords so now she can't go from the highs to the lows, can't sustain the phrases. She often says how losing her voice was the most humbling experience she ever had. "I sang all my life, and I thought I could just do it till I died, but it didn't work out that way."

Yet sometimes, you never know when, Evelyn's singing voice comes back for a brief moment, like at funerals of friends or while she's stirring berries into jam. She'll be hoeing a row of chile in the middle of the day when a spontaneous "Oh, sole mio!" will spring forth, her voice somehow finding her again, a dove alighting back on the windowsill.

Evelyn's grandparents and parents and aunts and uncles have all died, but their voices are still here, like grace notes, those little side notes you barely hear because they're played so quickly, so subtly, right before the bigger notes you're supposed to hear. Evelyn was given their music as she was given the trees. The wind plays their old songs.

I came across an old family movie of my dad, who died when I was a baby. I watched it, wanting to know how he moved, how he spoke, how he sounded when he laughed. He's talking, but there's no sound, just a silent figure in black and white laughing among friends.

My grandmother used to sing to me in the afternoons. "Oh bring back my bonnie to me," is usually how it started. She'd be hanging out thick cotton sheets on the clothesline to dry, one song leading seamlessly into the next. "Oh Susanna, don't you cry for me. For I come from Alabama with a banjo on my knee." I'd lie in the grass underneath, listening, the cool sheets dragging back and forth across my face in time with the breeze, in time with "By the Light of the Silvery Moon." I didn't know what the songs meant half the time. It didn't even matter. We sang the songs together, and that's just what we did. They stuck around with me like a good piece of advice. It was something we had that wouldn't change or melt or go away or die.

Hearing those songs again and I am home. Singing them is needing nothing.

All week long Evelyn and Joneve have been teaching music camp to a smattering of children gathered at the farmhouse. The living room floor is an obstacle course of tambourines and triangles, xylophones, drums, No. 2 pencils.

Evelyn starts them singing "It's a Small World." She calls out directions over their voices: "When you sing, honeys, you always have to raise your eyebrows so you have some puffiness." The kids all puff out their cheeks and stomachs and belt the words out louder and puffier—"It's a...small...world...after...ALLLLLLL!"—exploding into erratic notes and laughter.

Evelyn is undaunted. They'll get it; they already know what music is, way deep down, the rhythms and melodies there long before they learned

to speak, before they lined up at rows in school and were told the rules.

The children splay out across the floor on their backs and tummies like popsicle sticks, all red and orange and sweet. Evelyn puts on a recording of Saint-Saens' "Carnival of the Animals." She tells them to close their eyes and try to hear the animals.

"Just listen."

The children giggle and squirm.

Then they grow quiet as the notes fill the room, and they remember what they already knew. The music gets louder, and they start to smile as they see a whole carnival of animals coming to life right in the middle of Miss Evelyn's living room. Wild donkeys and plucky cockerels, graceful tortoises nosing around the harp, kangaroos pouncing across the keyboard. The oboe is now an elephant, and the swan floats by on a dream.

Evelyn brings them back as the music ends and they open their eyes.

"So, honeys, have you learned to listen to music now? The song of the swan is one of the most beautiful melodies you will ever know in life, and I want you to remember it."

She gathers her little baby birds and fishes to the piano so they can practice their scales and rhythms. Merrily, Merrily, Three, Four. Life is but a dream…

I sing "Red River Valley" to my little boy, especially when the sun's going down at the end of the day. He likes to sit in my lap so we can sway together to the melody. He asks me where the Red River is, and who is leaving it, and why, and will they ever come back. And I tell him, oh, it's just a song. And we start again.

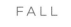

FALL

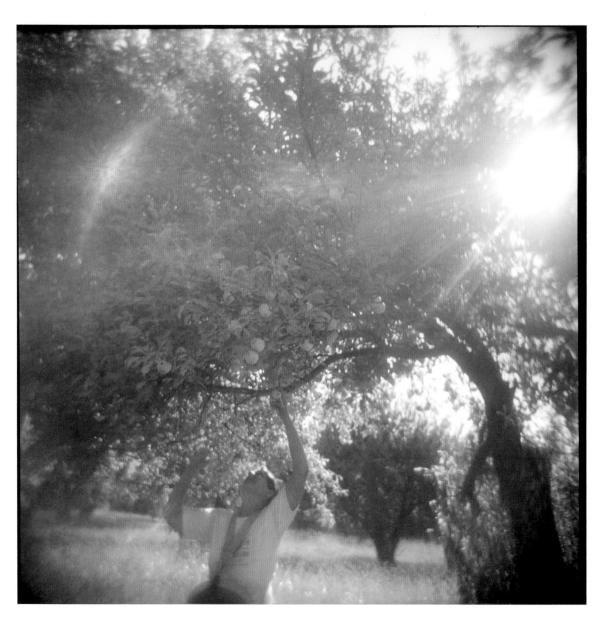

Joneve picking apples

SUMMER'S PRIZE

"What you get in the grocery store is a bunch of goop."

THE FARM THESE HARVEST DAYS IS GOLD and earthy, a ten-year-old at the end of summer, all tanned and callused and rule-free. Fruit isn't so much picked from the trees as it simply surrenders. Tomatoes fattened on sun and monsoon cascade over their caging and down into the furrows. Grooves form and split across the shoulders of the beefsteaks. Harvesting lasts past dinner. Why would you go out among your rows now without a basket? But you still do, and by the time you've reached the end of a row, you've filled the hollow of your stretched shirt with ripe tomatoes and handfuls of beans.

It is my first time this week scaling a harvesting ladder high into the apple trees. It's important to harvest apples just right—twist don't pull—or else you risk tearing off what will become next year's apples. Don't grip the fruit either or it will bruise. Just let it rest in the cup of your hand. We pick as much as we can, filling apple bags strapped to our chests as we balance atop ladders. Then carefully down, rung by rung, with our pregnant fruit tummies we open the bags gently, and the apples flow into the wooden crates below.

What isn't eaten or sold will be pressed into cider next month. We try to get all the apples on all the trees, but there are many and it takes a lot of time. It costs more to hire someone to finish picking and keep the cooler room running than Evelyn can make selling the

apples, so some will have to be forgotten on the trees. The crows will take passing bites. The rest will be put back into the earth as compost for another time.

Evelyn takes an old bank lobby curtain dampened with well water and drapes it over the apples under the pecan tree to keep them cool. She sorts them by variety. The solid and dependable Red Delicious, the school lunchbox apple. The asymmetrical and often maligned but educational York Imperial. The Arkansas Black, an apple which tastes like you've already made dessert out of it. The Napoleonic and vivid little Jonathan that commands your attention. The Macintosh, nicknamed the "sweet and sexy" by Evelyn's son—the Garden of Eden apple, red, tart, sweet, tempting. The muted Winesap, the wine's sap. The July Tart, an apple whose name Evelyn seems to change every year. This year it's the Summer's Prize. It's the first apple to come ready, so when it does you know everything the whole year up till then has worked and it's all going to be all right. The Summer's Prize seems a little small for most people's patience, but it's just right for bobbing or for fattening your horse. The Golden Delicious is just that and more—it's golden, it's delicious, it's what's under the caramel in Evelyn's famous caramel apples. But, alas, the goldens are like a summer day, they're only sweet for a while, and then they're done. This apple won't get you through winter, but who the hell cares? Carpe diem.

One Sunday at the growers' market a customer sampling one of Evelyn's apples says, "Hey, I think there's a little worm in here." "Really?" Evelyn replied, "Well, I'll throw him in for free."

Such exchanges give Evelyn a chance to step up on one of her favorite soapboxes: "There may be little marks on these apples, but at least they're not embalmed like they are at the grocery store." Quite often,

commercial fruit is picked before it's had a chance to ripen and fill with sweetness. Any fruit misshapen or too small is discarded. Homogeneity is the industry's standard of perfection. Any fruit that can't survive being shipped thousands of miles is generally avoided. Apples are inundated with pesticides to ward off any other life-form and coated in wax for shine. Then they're hit with gases and stored in darkened containers full of nitrous oxide to slow the aging process before being sent to the stores. In other words, they are embalmed.

Home-grown and homemade can wear the quirks and marks of its imperfect existence, the wrinkles and occasional blemishes earned from a life lived among sun and birds, spring frosts, summer hailstorms, winds from the west, things not anticipated.

The week started with the harvest of the potatoes my friend and I grew on some land off Toad Road. We planted them last spring, at a time when growing a big field of potatoes seemed a perfectly reasonable thing to do with our lives. Auntie Lena came through for us; her leftover alfalfa poking up throughout the field gave things a good shot of nitrogen. It felt good digging down into the soil and pulling out something real.

On the farm, the purple Cherokees Evelyn babied from seed saved from discarded tomatoes never make it to the growers' market. Evelyn hoards them instead, chops them all up, still warm from the sun, adds a little fresh jalapeño, bell pepper, maybe a peach, whatever she happens to have, for the day's fresh salsa. The cucumbers are crisp and snappy. We stash a salt shaker at the end of the third row.

An abundance is coming into harvest now throughout Corrales's farms and gardens. Mike's sweet Italian peppers that his daughters sell each Sunday at the market. Evelyn's sister Dorothy's deep red hot chiles and field of pumpkins grown on her plot of land down the way. The

Wagners' sunny yellow corn grown in the field next to us. Russell's mushrooms gathered at dawn by the river after the monsoons. Evelyn's wild, smoky purple plums, the color of an old memory, grown from seed her ancestors brought with them on the boat from Italy over a century ago. Cucumbers that started as tiny seeds in the hands of Evelyn's music students.

Pies are at their best now, warm with freshly picked fruit, full of arias and laughter and conversation at dawn. Anita's oregano dried on hot August nights. Honey from her bees that comes in light and golden in June and by now has taken on the rich amber and deep, sweet tenor of late summer. Ben's earthy sweet potatoes. (He likes to leave half his crop underground and dig them up on the day before Thanksgiving so his customers can have the freshest candied yams with their meal.) We're not just eating raspberries, either—they're Doug's raspberries from a field he tends by the bosque where he used to roam as a kid with his father, learning all about the world and how to protect his part of it. This is food with soul value that can't be weighed or measured. It tastes of place, our place.

A Navajo weaver once told me: Above all else, never weave when you're in a bad mood. All that negative energy will come out of you and go into your weaving, and there it will stay. Instead, she advised, put good thoughts into your creation, good memories and prayers, for those are just as real and powerful as the warp and weft, and just as enduring for whoever is given the weaving.

Perhaps, then, all those dreams we have when planting and nurturing a crop, all our great plans we forge while hoeing, our thoughts, our taking crazy chances, or creating second chances, our wanting to save something in the world, might somehow get into the very food we grow, which in the cycle that connects us all will be consumed by our neighbors and become their nourishment to feed their dreams, their plans, their work, their taking chances on something unknown.

I head out to the orchard on windfall duty to collect the apples that have just fallen but aren't damaged. It smells of musky earth and honey-summer. Crows call from the bosque by the river. This is their time of year. The grass, long and soft with summer, rich from years of living in the company of apple trees, is damp from last night's rain. The breeze blends the grasses and trees together into a wispy, gossamer green, the apples dissolving into little asterisks Dick-and-Jane red. Apples with a nectar so crisp and sweet it cuts across all that time back to when you were a child and you had an apple, a big red apple, and you laughed because it hurt it was so sweet and tart. But you only knew summer.

What a humbling thing to do, I think, crawling around on my hands and knees, gathering what apples may have fallen in the wind. It feels like going back to a place where I may have never been, or perhaps it's more like visiting a place I always felt existed, or should exist.

My knees are wet with autumn and apple. I think it is perfect here.

"I DIDN'T KNOW WE STILL HAD FARMERS"

"Honey, it's just a pig in a poke, it's not gonna accomplish anything for me to say something. But I'm not going to take it lying down."

DURING THE LATE SUMMER OF 1985, Evelyn called the editor at the *Corrales Comment* with an idea: we have all these apples, why not throw a big party. The Catholic Daughters of America down at

the church had been putting on wonderfully popular harvest dinners every October. Why not expand the harvest celebration on the farm? Folks pitched in to get things going, made some posters to hang around town, helped clean the barn. The event was staged for mid-fall, and a crowd, mostly just Corrales folks, showed up to buy the season's fresh chiles, corn, beans, pumpkins, pears, and, of course, apples and cider from the local farmers. Johnnie hitched a wagon to the back of the tractor, filled it with hay bales, and drove everyone through the orchard. Every so often he'd stop, and all the kids would jump off, run around the trees, pick some apples, then hop back on and sink their teeth into autumn.

Today, the Harvest Fest draws thousands of people from the whole metropolitan area. Corrales Road gets closed off for two days, and traffic snakes around narrow back roads throughout the village. The Pet Parade kicks the whole thing off Saturday morning with horses dressed like scarecrows and little red wagons pulled by goats carrying chickens and children. Some people come to stock up on fruit and vegetables at the growers' market or to purchase a sack of fresh roasted chile or jack-o'-lantern pumpkins from Wagner's farm stand, but many more come for the entertainment, Kettle Korn, and meat-on-a-stick. Guitarists hook up amplifiers, and the fire department has a big dunk tank. There are many painted gourds.

At times, it can feel like the "harvest" is a little far removed from the "fest." A festival volunteer once asked a young farmer if they could use his field for parking. The volunteer was a little perplexed when the farmer said no. The field was an actual, real working farm still full of blue corn.

Evelyn likes to drive slowly down to the orchard, Goldie in her lap, just to look things over. She casts her hand and her gaze out the open window toward a row of Winesaps and Macintoshes, the farm truck trundling down its own familiar way. "Aren't they beautiful," she says.

Last cosmos of summer

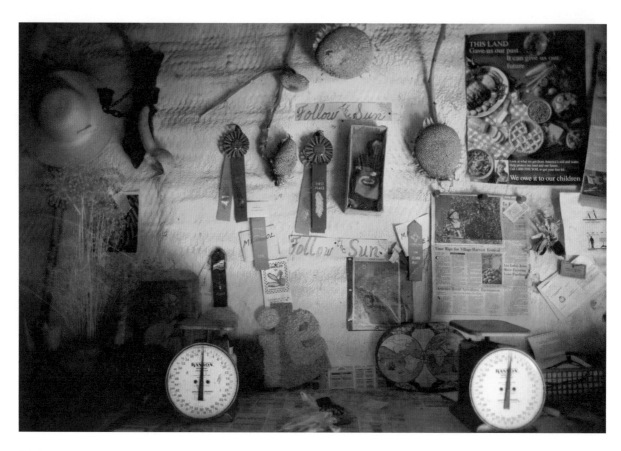

The barn

The Curtis-Losack farm used to sell a lot of apples. Evelyn remembers as a kid loading up wagons full of her farm's produce. Her dad would stitch together two or three nonworking vehicles into one makeshift working vehicle, and the family would head to town with their goods, crossing the river on the old bridge where you could look straight down through the gaps in the boards.

Once in town Evelyn and her family would trade at Franchini's for the things they couldn't produce on the farm, like sugar, flour, olive oil, and dried cod called *bacala*. They'd go door-to-door through neighborhoods with their fresh produce. What they didn't sell in town they sold by the side of the road at their farm stand. People from town would clamor for the country, excited to see the first apples of the season. They'd buy extra to cook and can as applesauce for the long and otherwise fruitless winters. It was a different time.

After Evelyn's father died in 1962, her mother loaded apples into four-pound bags, took them into town, and sold them for thirty-five cents a bag at the Globe Market. Evelyn's son Mark put the thousand dollars he had been saving since childhood toward a van his grandmother helped him buy so he could deliver the produce.

These days, Mark grows on his own land on the sandy side here in Corrales with his wife Veronica and son Lorin. Mark learned a lot from his grandmother. Veronica is from an old farm family, too, the Targhettas, so the land is also in her blood. They grow their own tobacco and make their own wine. Veronica grows tender eggplants and raises the happiest chickens for their eggs, which she takes to the market every Sunday. The two are always trying something new. They once tried to explain hydroponics to Evelyn, but she didn't get it. ("What about the soil?") They farm all spring, summer, and fall, but they can barely keep up with the high property taxes alone, the land valued so much more for what can be built on it than for what can be grown.

There is land here, and there are farmers. But the two can rarely hold on to one another.

When the old bridge was replaced in the fifties by one that could actually be driven over safely, more and more people from the city discovered Corrales and the country around it. Change came along for the ride. In the early 1970s Dulcelina Curtis and others successfully fought to get Corrales incorporated to protect it from being swallowed up by the city. Many times in the years that followed she, as with many of her neighbors, was approached to sell her land, but she kept saying no. Her family had worked too hard for the farm. "The land will still be there, but the money will all be gone," she used to say.

One of Dulce's hardest days, Evelyn will tell you, was the day Phil Modica came over and bulldozed down 250 Rome Beauties and 300 peach trees hollowed out and dwarfed by drought. She had cared for those trees like a mother, but in the end it wasn't enough. "You can't change the world," she told Evelyn. "You have to take life as it comes."

Down came the trees.

Once I was in the grocery store with Evelyn. The cantaloupes were on sale for 99 cents. She looked deflated. She said to the produce stocker, "Honey, we can't even pull them from the field for that. What about the poor farmer who grew this and broke his back and made nothing?" He answered her, "Yeah, but *we're* making money."

That November Evelyn and another old-timer, Richard Martinez, pulled up their trucks alongside the road, dropped their tailgates, set up tents and unloaded apples. They talked about old times as people drove past on their way home from work. A woman stopped to see if they still had tomatoes. Their only customer picked out three dollars' worth of Delicious. Evelyn had to search through her truck trying to make change. Two hours passed. The sun went down. It grew cold. Times have changed, they say; times have changed. They packed up their apples and went home.

Franchini's place, where Evelyn's family used to trade apples for fish, is no longer in business. Most groceries around here now are part of franchises with home offices out of state. They generally don't want to deal with individual small farmers whose supply lines are dictated by such things as weather and the fates. Instead, they buy by volume from large growers elsewhere.

It's hard making the numbers work on a small family farm. By the time you buy the seed, buy a tractor, prune the trees, fix the tractor, install the irrigation, wait ten years for the trees to produce well, harvest the fruit, cool it, store it, and get it to market, you'd have to sell a whole lot of apples to keep it all going. Toward the end Johnnie subsidized the farm with his pension. He would say that if they didn't have a crop that year because of weather or whatever the farm would lose $5,000. If they did have a crop, they'd lose $10,000.

Evelyn says it comes down to this: You put your heart and soul and your family's heart and soul into this land, and you want to keep it all going, but it takes more. What do you do? Do you or don't you? Year after year.

Everyone who's shown up at the farm this week has been put to work preparing for the harvest festival. The Mormon boys picked several bushels of apples and pears. Michelle from down the road showed up in between shuttling her kids around, work, and waiting for the cable man, to help pick. The owner of the dog kennels helped sort fruit over breakfast. Even "gardening sucks" Tony is out in the field. He shuns the offer of fresh corn on the cob, still plump and silky. "I like my corn straight out of the Coke can," he says.

By the end of the day at the end of the week, the fruit has been sorted and arranged, the vegetables washed and bunched. Evelyn moves to the kitchen, where her work has only just begun. I tell her about

an encounter I had with a woman who lives on the edge of Corrales. When I mentioned to her that I was on my way to the farm to help get ready for the festival, she looked a little blank. She knew about the festival, but no, she didn't know Evelyn, didn't really know where her farm was. "So," she started, sounding as if she were adding something up in her head that just wouldn't add up, "what exactly do farmers do?" I thought about that for a minute then muttered something about apples and chile and other things that are grown around here. She looked back, incredulous. "Wow. I didn't know we still had farmers!"

Evelyn's too busy with her cooking project to hear about my encounter, or maybe she just pretends not to hear. She dusts pieces of fresh-dried fruit leather with a titch of powdered sugar and rolls them into little diplomas. Out comes the beloved *Noridge Co. Cookbook*, where, tucked in between the pages, is her mother's old caramel apple recipe.

For years, Dulce would spend Friday nights making caramel and candied apples to sell. She did everything she could to save the farm. Now Evelyn has taken over the job. It's late. She's been going since before sun-up sorting apples, and it's now past dusk. She stirs condensed milk with butter and corn syrup into a rich, thick stew of caramel. It turns from white to golden. She dunks the green apples, one by one, into the warm caramel and sets each one, dripping, onto sheets of waxed paper.

I think of the Jonathan I saw earlier in the orchard. It was so burdened with apples waiting to be harvested but not enough hands to do the job in time. Branches scraped the ground and had snapped off in some places. The tree was too old, too singular, to bear alone the weight of a good year.

Evelyn disappears into the pantry and emerges moments later with a huge box of Rice Crispies. "Might as well use these all up!" she exclaims. "The kids won't care, and nuts are too expensive anyway." She pours a big bowl and twirls the sticky apples in it.

I ask Evelyn if the Golden is really the best dipping apple, and just how hot does the caramel have to be before you can dip, and then I ask

her what becomes of all this when she's no longer here, what her kids and grandkids will do with the farm, this land. The caramel gurgles as she dips another apple in the pot. She gives it a gentle stir.

"I don't want to think about that, honey."

So we don't.

After a pause, she asks, "Do you think I'm nuts, honey?" She dips another apple.

"How so?"

"For doing this."

"You mean using the Rice Crispies?"

"Other people are just selling their land, and I'm doing all I can to hold on to it."

Evelyn turns up the kitchen radio. "Listen, honey. It's Chopin."

Music fills the kitchen. Rows of sweet green apples line the counter. The caramel has already started to harden to a shiny glaze.

LISTENING TO PICTURES

WHEN THEY BURIED AUNTIE LENA, my boots sank deeper into the sand as we stood there among the graves against a cold wind out of the west while from the east a morning sun flooded through the cemetery gate, watering our eyes, blending tombstones with trees. A figure took shape and moved toward us, a white bird floating into a parting flock of black; the priest has arrived now in flowing funeral robes. It's time. As the casket is lowered, Evelyn in mid-prayer whispers, "Good-bye, Auntie Lena," to a whole generation that had become the past tense.

Days spent with fragments, half-remembered stories, unidentified images. I'm on a chair in Evelyn's hallway, handing down from the hall closet boxes of photographs, leather-bounds encasing the oldest images, brown brittle envelopes full of certificates for past deeds and accomplishments.

Here is a family portrait: Evelyn between her parents on the farm, her father inexplicably in top coat, suit and vest buttoned all the way up, white handkerchief, Evelyn looping her crossed hands through his arms, her mother's arm hooked into hers, her little sister's incurable grin. Beneath the photo: "Curtises, 1941-2-3?" What was going on in the moments before this? And what happened then, after they unlocked arms? Another, a man next to an unlikely Ford with a salvaged truck bed and mismatched tires, the metal hammered out above them to improvise rims. The notation: "Dad made another car from parts."

Here is Evelyn as a young girl, jaunty and self-assured, sitting in the shade of a tree, a sandwich in one hand, a bottle of Coke in the other, hair pinned up under a bandana.

Another photo: Johnnie and Evelyn just married, sitting on the porch of their new home, a horseshoe pointing upwards nailed above the threshold. Johnnie looks just like his son, not yet thought of, the one who died a year ago.

Flip through decades, a woman on water skis behind an unseen boat, winningly waving her right arm at the camera in a see-what-I-can-do pose, her mouth wide open as if in song.

Dulcelina the matron in so many pictures, out in the fields, in the orchard, strong eyes under a big hat. In later pictures, seated and surrounded by her children and grandchildren looking as if they're in the middle of filling up her plate or giving her a hug good-bye when they turn and smile for the camera. Dulce on her hands and knees tying chile, the image fading over the pages into Evelyn on her hands and knees tying chile.

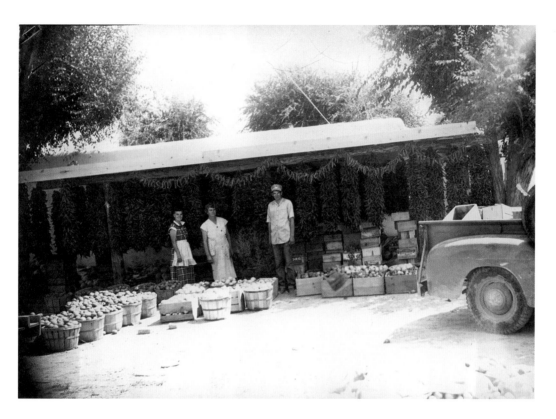

Roadside Curtis-Salce farm stand, 1950's.
mother in the middle with her apples and
hand-tied chile ristras, mrs moreno - left
and Emil Leplat - right.

And then: a picture of the Curtis-Losack farm stand, walls unseen behind ristras of chile, a truck backed up to unload bushels of apples, apples everywhere, boxed and crated. Two women and a man stand with all the grace and composure of people who have paused just long enough from their back-stooping work for the photograph. They stand in their moment with nothing to prove: this is who we are, and this is what we do. They do not know a world without them.

They are saying something. Can we still hear it?

HOW TO SLICE AN APPLE

*"What I can do, I do. What I can't, I don't.
And I don't worry past that."*

ALL SEPTEMBER LONG people have circled Evelyn's booth at the growers' market craving that distinctive taste of being a kid in the late summer—apple butter. Evelyn obliges. At the farm, it's the day before the autumn equinox, and apples are warming on the stove. Vivaldi's ushering in the new season from the kitchen radio as Evelyn preserves what remains of summer. She is perched on a little stool wedged between stove and sink, where she's spent the last several hours sorting apples and running them through the colander to make the butter.

Out back, much of our chile except for a couple rows looks wilted and spent. Despite the best plans and lots of back work, a clever watering strategy, and years of wisdom behind it all, in the end it succumbed to virus.

That on top of a second late-summer planting of beans which didn't seem to germinate. I ask Evelyn why. She starts in about "them" repackaging old seeds and that leads her on a tirade against Wal-Mart, goose-eating coyotes, and the mess of elms that are sucking up all the water beneath Corrales. And then: "Honey, sometimes it just doesn't work out."

She heads toward the porch. "Let's have a break. I want to show you how to cut an apple in case one day I'm not around." I didn't realize I still needed to learn this, but I join her at the back porch table anyway, where good things happen.

As with many endeavors, first you divide it in half. Evelyn shows me the insides of the apple, the very heart of it. "See those lines?" She carefully studies the lines at the center of the fruit like she's analyzing tree rings. "Those are the lines of sweetness," she says, explaining that the tracings form only when an apple has been allowed to ripen fully on a tree. Not like with the embalmed ones you buy in the grocery store picked way before their time.

If you suspect you may have a worm in the apple, she advises, don't cut all the way through to the center. Just take what's good and leave the rest behind. If you do go all the way through, all you're gonna find is a wall-eyed worm toilet in the center, and then what are you going to do?

Evelyn steps back inside for a moment to find her favorite paring knife, the one she hides and wants to be buried with. She comes back to the porch; the porch door swings behind her and something has made her think about Johnnie, and she begins to tell me a story.

Johnnie was seventeen when he enlisted in the marines after Pearl Harbor was bombed. He told Evelyn some things about the war when they met, like how he was on Okinawa when Ernie Pyle was killed. How he saw the flag raised on Iwo Jima. How he got malaria and elephantitis so bad they took him to Guam to die. How they were all dressed up, ready to invade Japan, when Truman dropped the bomb and the war ended.

But other stories Evelyn wouldn't hear about until much later in life. Like the time he was stationed with his radar team on an island in the South Pacific. One late afternoon Johnnie wanted his buddies to help fix up some airplanes in the hangar. No, they told him, they had just had mail call and dinner, and now they just wanted to hang out in their barracks reading letters from home and sleeping. Johnnie went to the hangar by himself. Somehow the Japanese planes managed to fly under the radar. They dropped bombs on the barracks. Johnnie was thrown into a ditch by the explosion. He survived. His sixteen buddies in the barracks did not.

Evelyn removes the apple's skin in one long, deft scallop.

"He never got over that."

She removes only the core, nothing more, careful not to cut into the perfect sweet moon at the top of the apple that's just right for drying. She makes you believe you've never really sliced an apple right your whole life, yet it's one of the most graceful things in the world to know how to do, like waltzing.

Every part goes somewhere—one bowl of moons to dry, another bowl with slices for pie. The worm toilets and the butt ends of the apples ("where all the pollution likes to hang out") will feed the ducks or next year's soil.

Past the porch, pecan nuts fallen from the trees have been nudged off the grass and arranged like blue notes on the drive, waiting to be run over by cars heading to the barn so the birds can eat. The sunflowers are starting to bow, heads heavy from following the sun all summer. Beyond that and out into the field, most things are done for the season. We're letting what chile we did manage to grow stay on the vine for a while to turn from green to a deep, sweet-hot red.

We head back inside to check on things. Evelyn pauses over a big pot of apples bubbling on the stove and swirls them down into a warm,

Sunset over the Sandia Mountains

halcyon butter. We check the peach vinegar. It's fruity and strong, heady and sour. It will be a few more months till it's ready. I add fresh dill to crocks of pickling cucumbers.

Evelyn is quiet. Stories and things not thought of for a while still linger in the spaces left behind. She motions for me to come over to the piano.

Ever since Harvest Fest she's had this song replaying in her head, a John Denver tune, she tells me, that was played at Johnnie's funeral.

"Sing along with me." We share the bench.

Evelyn's voice isn't the same as it used to be, but she sings out anyway.

"Some say love is holding on, and some say letting go…"

She struggles for the high notes as I struggle just to find the key, and we don't sound all that great, but who cares and why not, it's Wednesday.

And we glide over those notes like they were blades of grass.

"Oh, I've got clothes to hang out on the line." Her song done for now, Evelyn trails off the piano and out the back door, munching a freshly dug radish.

Time for me to get back to things, too, I think, so I set out for home with my catch of the day: a warm jar of apple butter, a big jar of still-pickling pickles, an old kitchen apron I had admired on Evelyn, still wet from the wash ("Here, honey, you can have it, it's too tight across the boobs"), and a John Denver song stuck in my head.

I can hear her singing at the clothesline, and I call out: "Evelyn, you still have your voice."

"Oh no, honey, it's gone. It's only because I ate that radish." And she starts in on a new tune.

"Summertime. And the livin's easy. Fish are jumping. And the cotton is high… "

A wind from the west came up, just as the weatherman said it would, a big wind, bellowing through Evelyn's sheets, blowing out the last of

summer, trying to make space for October. Big clouds had formed while we had been stirring apple butter. They gathered now in the sky above the mountains and the valley and the river, clouds the color of Payne's grey, that shade of grey Midwestern painters must have, mixed with fluffy apple-flesh streaks of white. The sandhill cranes will be returning any day now.

CIDER TIME

"The only thing I like about rules is to break 'em."

THERE'S A SECRET WISH FARMERS and growers start dreaming about these days, something they seldom talk about and rarely admit to. A longing for the event that will simplify their days and lengthen their nights. First frost.

Our wish came unexpectedly out of the west early this year, on the first of October, leaving Evelyn heading to market with just a few bouquets of cosmos, the last of the quelites, some very ripe pears, and a few trays of apples. She's still not quite sure if they're Virginia Winesaps or Arkansas Blacks.

Jeff Radford, the longtime publisher/editor/writer/photographer/ and deliverer of our steadfast *Corrales Comment,* shows up at the market in his blue long-sleeved shirt and jeans, gentle demeanor, and the purposeful stride of a small town newspaperman. Evelyn calls out, "Jeff, are these the Virginias or the Arkansas?" Jeff pauses. He has a few fruit trees of his own. "Well, Evelyn. I've been calling mine Arkansas Blacks because that's what you've been calling them."

There's talk now of our big communal Thanksgiving meal next month. Evelyn will do the ham, turkey, and pies; everyone else should just bring what they have.

Back at the farm, work starts a bit later and ends a bit earlier. Things have slowed down in the long exhale of a harvest ending. Crows hover in half circles, black commas punctuating the sky, then descend into fields of stalky corn and chile, where they poke about and pause before rising up again. They are joined by the first sandhill cranes. Winter isn't far away.

Evelyn's grandson Jeffery arrives mid-morning and fires up the cider press, just as he has done every autumn since he was ten. He's thirty-one now. He learned from his grandpa, who helped Evelyn's dad convert an old wine-grape press into an apple press more than a half-century ago. Vincent Curtis realized pretty early on in the apple business that he needed to find something to do with the leftover apples. So away he went one day in his blue pickup, heading back East to Connecticut to buy a cider press he had heard about. He didn't come back with the press in the back of his truck; it didn't quite fit. But he did return to the farm with dreams of building his own.

The barn surges with life as the press starts once again. Over the years, Vincent's improvisation has been modified, reconfigured, jiggered and rejiggered by grandsons, sons-in-law, great-grandsons, and whoever else comes up with a good idea. The boys have rigged up a clever system comprised of buckets, grinders, a pulley or two, some belts, a swamp cooler motor, and a recycled water softener bag that acts as a chute sending apples into a seven-layered sandwich of frames that squeeze the fruit when tightened. The juice flowing from the press passes through a vacuum-type piping system that takes it from one side of the barn through the wall into a 250-gallon tank on the other side, where it can settle before bottling.

Pressing cider is the kind of work that attracts the menfolk around the farm. Big containers are heaved and dumped to allow the contents

Sorting apples under the pecan tree

to run through various grinders and smushers that turn solid into a liquid that could potentially be made into liquor. The process has a clear start, an unambiguous end, and not much time in between. You don't have to handle anything with too much care, and you get to use tools, since inevitably something breaks or needs tinkered with.

Jeffery dips the next batch of apples in cool water. Vince and Gary hover over some pulley or something that's not working right, talking in shorthand I can't quite make out. Vince pounds on something with an improvised hammer, while Tony fires up the tractor to scoop up apple remains and drive them to the compost heap. At one point over the loud music and engine roar, someone declares, "It's beer-thirty!" and out come Tony's Bud Lights.

Last year, a late spring freeze nipped the apples for the season, meaning no cider in the fall. But the year before last was good, with the Curtis-Losack farm pressing and squeezing over five hundred gallons of earthy-golden cider. This year the apples are abundant, and the cider will be, too. Evelyn likes the boys to use a variety of apples for a batch. Her way can transform cider into something a bit more than the sum of its parts. In goes the Red Delicious for its body. Golden Delicious for sweetness and clarity. Tart Jonathans, earthy Winesaps, rich fruity Yorks. Maybe a few pears for good measure.

Cider made the old way is pure. In it, you have a year's worth of work and weather, nothing else. It's alive. Since homemade cider contains tiny bits of fruit and yeasts of the apple, it's often stronger and rangier than its grocery-store counterpart, otherwise known as "apple juice," which is filtered of its apple parts and zapped and pasteurized to kill active yeasts and extend shelf life.

For years, Evelyn sold her apple cider to area grocery stores and at the farmers' markets. People could drink from the local vine. Then new regulations banned sales of unpasteurized juice in the stores. Evelyn's daughter had the inspector out to the farm to show him how they've

been doing this for years. How banning the sales would devastate a family's fifth-generation farm. But rules were already in place and times had changed. Evelyn was given a choice: either invest in $50,000 (plus shipping) worth of pasteurizing equipment and convert the barn into a big steel wash room with new floors, new ceiling, new everything, or stop selling her cider.

Evelyn's cider is no longer found at the grocery. She says its regulation like this that kills the small farmers in lost sales and morale. She's convinced that sticking the damn glass of cider in the microwave for a minute and a half will do the same thing if anyone's worried.

If you pull up outside the barn and honk, and if someone's around, you can still get a bottle or two of the real thing. Only now it goes by a new name with a warning label: "Caution: Unpasteurized Apple Juice."

The sound of juice trickling from the frames means the cider is starting to flow. Evelyn isn't around to enjoy the first taste of the season—they were broadcasting an opera at the movie theater in town—so it's just me and the boys. I suggested a toast. Vince shakes his head. He was so sick of apples at one point in his life that he refused to eat them, for like ten years. Of course, Tony hates cider, and Jeffery seems to be suffering from some ennui as well. "Every day of Grandma feeding this stuff to you, and you'd be sick of it, too."

Vince finds a cup in the front of his truck and shakes out the old Coke. I drink three cups worth, dreaming of making some cider-infused butternut squash soup. I tell the boys about this. Tony spits out some chewing tobacco. "Oh shit, just let it turn hard." That sends the whole discussion to the best way to harden cider, something about a twirly straw to draw it out of one container into another without capturing oxygen, letting the yeasts do their thing with the sugars, and voilà—liquor. Just don't feed fermented apple sludge to a pig, which is what happened one time on the farm. Everyone just thought Piggy was sick

when she couldn't stand or walk straight. Then Evelyn's nephew Curtis realized he had fed her apple pulp left over from making apple wine. Poor Piggy finally sobered up after about three days.

For the next few weekends through November, the boys pressed all they could of the season's apples. Evelyn will sell what she can how she can. The rest she'll save for Historical Society gatherings at the Old Church, just like her mother did, or let it transform into vinegar.

The press is sprayed down, apple crates restacked until next year, the tractor parked. Folded into the days is a deepening quiet of the time to come. Evelyn wraps up the last of the fruit leather, which has dried to colors deeper than the fruit it came from. She hooks the latch on the barn door and heads for the house.

Remains of Sunday morning bouquets

WINTER

HOT TAMALES

"Honey, I don't mean to brag, but the jam that's on the stove
is the best jam anybody's ever made. Ever."

DURING THE FIRST FEW YEARS I LIVED
in Corrales, I rented an old adobe house in the
middle of an old apple orchard. The wooden floors
were warped so that the kitchen table sat a bit downhill from the rest of
the kitchen. The well had been cut shallow into a minerally landscape,
so every time you took a shower it smelled a certain way that water can
in Corrales, and you'd find yourself thinking about the Periodic Table.
But I slept every night with cool, thick adobe walls all around me, like
a grandmother's arms. My landlord, Jimmy Gutierrez, would stop by
for the rent and always ended up staying for coffee, telling his stupid
jokes around the leaning kitchen table, lapsing into stories of growing
up on the farm helping his mother, whom I later learned was Evelyn's
Auntie Ida. When some of the stucco broke off years later from across
the front of the house, it revealed the adobe underneath with part of
a hand-painted word: *FAR*. Apparently my old house was Auntie Ida's
old farm stand.

On Christmas Eve day, Jimmy would fill brown paper bags with sand and candles as generations before him had done. He would place the *luminarias* around my casita and the farmhouse next door where he grew up. At sundown, he'd light them, and the night would glow.

Around this time, Jimmy would also invite me to his home down the road, where the family gathered to make and share tamales. There's nothing like the traditional New Mexican tamale, especially on Christmas Eve. Stuffed with sweet homemade masa, family-secret-seasoned pork, red chile blistered and spirited by the New Mexican autumn sun, all rolled up and steamed in corn husks dried back in the summertime.

Tamales may go down as easy as Christmas cookies, but actually making them by hand is another matter. It's like churning your own butter or making your own vinegar. It takes the day. It takes the night. It takes every single pot and pan in the kitchen. Kinfolk are involved. And it takes all this being done right in the midst of last-minute holiday shopping, cleaning, wrapping, baking, rooting for Double-A's in the junk drawer, decorating, and office partying. It's so much trouble, why not just stop on your way home and pick up a dozen or two take-out instead?

Jimmy died a while back. I never did get over to help make tamales. I got caught up in the something that holidays can become if you're not paying attention. So when Evelyn called this year and said, "Honey, don't you think we should be making tamales?" I dropped everything. Cookie dough, unwrapped presents, dirty dishes, unassembled Big Wheels. It was time.

I show up to Evelyn's bearing a warm and tender roast that had simmered all night on a slow stove. Jen starts to prepare ten pounds of masa. Our friend and neighbor Ollie from Mississippi stops over during a break from Christmas shopping. "I can't cook tamales, but I can at least keep y'all company," he says. We gather around the kitchen counter and put on the coffee.

It's a good time of the year. Not just because of the holidays but because our hard work can finally be unshelved, uncorked, and enjoyed.

Pickles are finally pickled; the vinegar's ready; fresh summer tomatoes are now winter's salsas. Evelyn stumbles across the cherry bounce forgotten and fermenting for months in the back of the pantry. Out come the pits and in goes some vodka.

We ask Evelyn what we do now to make the tamales. "Well," her voice trails off.

"Aren't you all a little hungry for a little snack first? Why don't I whip up some Corrales-style chile rellenos? Have I ever told you all about the rellenos my Auntie Ida used to make?"

Evelyn breaks out the tin of the house-specialty homemade peanut brittle her son-in-law Gary dropped off earlier and passes it around as she fires up the stove. Many years ago when Evelyn and Johnnie were getting married, Auntie Ida—Jimmy's mother—asked what they wanted for a wedding present. There was no question: they wanted her famous rellenos. At eight o'clock on the morning of August 20, 1949, Evelyn and Johnnie were married in the Old San Ysidro Church. Auntie Ida had made enough rellenos for the whole village, it seemed, and they were all gone before lunch. The happy guests stayed well into the night as Dulce and the aunties continued to turn out specialties from the kitchen.

It's starting to become apparent that somehow the village matriarch is not completely sure how to make tamales. Evelyn gives her daughter Joneve a call to see if she can help out with a recipe. Joneve can't really cook, bless her heart, but she can Google. We keep her hanging on the phone line as she taps out TAMALE, then RECIPE. Apparently she got stopped last night by the village police at a holiday road block on her way home from the St. Nicholas party, where she was helping Evelyn—Mrs. St. Nicholas—distribute apples and candy to the children. As the policeman started grilling her with questions and asking for the registration, license, proof of insurance, etc., Lady Cop comes over to the car, sees who's driving, and waves her right through. "Let her go. They do pickles."

Evelyn sets down the phone while Joneve searches for a recipe. She hands Ollie a handful of old-lady soaps and single-serve coffee samples. "This isn't a Christmas gift, I was just cleaning out the cabinets."

"Ma, are you there? MA?! YOU'RE GONNA NEED SOME CORN HUSKS AND SEVERAL POUNDS OF LARD," booms the voice on the other end of the phone, but Evelyn has already forgotten Joneve and is busy passing out some leftover fruit pie. "My Uncle Doc Mancuso in Lake Charles, Louisiana, used to make tamales," Ollie starts in on one of his stories. "They found the recipe somewhere and decided to go into the tamale-making business. They had a couple bars back then…."

"Did she say lard, Evelyn?" Jen asks with some concern, as her arms slowly sink to the elbows into an expansive pile of corn masa and water that's slowly taking over the kitchen counter. "Lard. Really?"

Ollie begins, "Mancuso's Tamales, that's what they called them. They called Uncle Henry 'Uncle Doc,' but he wasn't really a doctor. He used to do those magical elixir medicine shows in his backyard when he was a boy, and everyone just got to calling him Doc. Then he started making tamales. When he was buried, I couldn't figure out what was wrapped around his fingers. I mean, usually they put a rosary in the fingers, so I asked his son Henry, 'Henry, what's that in your dad's fingers?' And it was corn husks. From the tamales."

"How about some of those brandied peaches?" Evelyn scoots past Ollie and the masa and disappears into the pantry, reemerging moments later with a jar of white peaches eternalized in Bulgarian brandy canned back on some hot and crickety autumn night. I go for several spoons.

"I once had a crawfish tamale in New Orleans," Ollie starts in on another story. Joneve has apparently hung up to find a vat of lard, when Evelyn declares from the behind the stove, "We're in a pickle! We're in a jam! Who knows what to do?" She decides it's finally time to break down and call her daughter-in-law for the recipe. Veronica will be right over. "Ode to Joy" cracks over the kitchen radio, and we soak some old

corn husks in a bath of warm water. We peel some of Gus Wagner's Sandia Hots and shred the meat.

St. Nick from the party last night appears at the back door, minus the red robe and crown, to return the tractor keys to Evelyn. He was supposed to ride in on her old Farmall, but it was too cold so he caught a lift with the fire truck instead.

By now the stories around the kitchen counter have taken a turn. Evelyn launches into juicy sagas of Corrales's darker history, the dead bodies buried along the ditch, ghosts that linger in certain places, corrupt police, bootleggers, trysts and things introduced with the qualifier "Now you didn't hear this from me...." Jen makes a roux.

The back door swings open again, and Allen of Jewish descent pops in through the kitchen door, not so much to wish Evelyn a Merry Christmas but perhaps, if she could, if it's not too much trouble, lend him a few apples for a pie. Evelyn scolds him for waiting so long to buy apples—"Where were you when I was standing and freezing at the farmers' market all morning trying to move this fruit?"—yet she somehow manages to find him a half-dozen red and plump apples for his pie. And no, unfortunately, Allen doesn't know how to make a tamale.

On Allen's heels comes Evelyn's daughter-in-law Veronica Alary Targhetta C'de Baca Losack with the Family Secret. She produces something scribbled on a half-torn sheet of paper. A hush descends upon Evelyn's kitchen. We read over it, quickly at first, then more slowly as we start to calculate and contemplate the amazing proportions of masa and meat and...lard.

I try to sound casual. It's the family recipe after all. "So, that's a pretty large amount of lard called for there. Ever think about maybe substituting some eggs instead to help hold the masa together? Sort of like a big meatball?"

Veronica sets the recipe on the counter. "Just use the lard, and don't ask." She heads back out the door, wishing us well.

"Do save me one."

Tamales

15 lbs. masa (mix the cornmeal with lots of lard)

15.7 lbs. meat

5 blenders of red chile with 2 cloves garlic each

Salt to taste

Blend chile thick

Seasoning

As with most family recipes, the proportions may be written there, in plain numbers, tested and modified over countless birthdays, funerals, Sunday dinners, but the secret, the soul, exists somewhere unwritten between the lines. I have my Nana's Poor Man's Fruit Cake recipe she scribbled out years ago on the back of an old envelope in the beveled script of a pencil sharpened with a paring knife. She lists the ingredients—flour, sugar, cinnamon, plump raisins. Where she's listed "strong black coffee," I know that means you should brew a big pot so you have enough left over to pour yourself and whoever stops by a cup or two while the cake's baking. Where she says "baking soda," that's the cake's inexplicable chemistry—add the baking soda to the coffee and watch it fizz and pop and dissolve. "Bake until done" means that you could play a couple games of Go Fish and King's Corner and a round or two of Gin Rummy and that would time out about right. She baked the cake every year, only for Christmas Eve, and always in the same cake tin, browned with the perfect patina that comes from making the same thing over and over.

Everywhere in Evelyn's kitchen are pots filled with slowly steaming corn husks. The chile's getting pretty thick, as instructed, and we take the liberty of interpreting "seasoning" to include some of our leftover calabacitas and some cinnamon. We tie our little creations with kitchen string and line plates, Ollie filling in the empty spots with stories.

Evelyn talks about when she was a girl growing up in Corrales. Back then no one had much of anything. Her father would bring home a tree from the lumber mill for Christmas, and they'd decorate it with whatever they had—chile, popcorn, little paper rings. Her Auntie Ida and Uncle Marcos would usually slaughter a goat, Auntie Lena a pig. The whole family would share whatever they had. On Christmas Eve, little children from the valley would go door-to-door and exclaim, "Mis Christmas! Mis Christmas!"—"My Christmas, My Christmas!"—when the door opened. Families would give them a little candy or an apple, whatever they had to share.

On Christmas Eve back home, we'd all head over to my grandmother's house after midnight Mass for scrambled eggs, Long's donuts, and hot coffee. While the adults lingered in the dining room around candlelight and good China, I'd fall asleep warm and full of holiday in the back room on the coat bed, that ultimate spot of childhood comfort, lost and tangled among piles of thick wool coats and scarves that smelled of Wind Song perfume.

Jen talks about the undying image of her grandmother getting ready for Christmas Eve, toeing around the house in nothing but her slip, her hair done up, jewelry all in place.

Evelyn wonders what other people in other parts of the world are making together this time of year, how perhaps they've gathered in their kitchens with friends, back-door guests dropping by, generations linked by their stories and handed-down family recipes. I hear Evelyn start to say something about what she considers the most important thing in life, but I couldn't hear what it is because I'm in the bathroom singing the BINGO song to my boy, who is potty training. When I ask her later, she says she doesn't remember what she said, that it doesn't really matter anyway. She hands me a hot plate of Auntie Ida's chile rellenos instead. "Here, this is more important."

Eighteen pots (nineteen if you count the roaster) and nine hours later we have produced a stunning tray of tamales to feast upon and take to neighbors on Christmas Eve. It's late afternoon; the snow is steadily falling between the farm and the river and the mountains. Vince is in the field out back leaving a trail of expired bagels from the pantry for the sandhill cranes and geese to feast upon. The cranes descend, spindly and elegant all at once, grey etch-a-sketch figures picking their way through the orchard. The dogs chase after Vince and his trail of stale bagels.

So much still needs to be done, I know. But it can wait. Now it's time to head home, build a fire, and make my Nana's once-a-year cake with my boy.

WINTER'S TIME

"Don't bother with taking glucosamine for your bones. It's just too expensive, and you have to take three every day. Just eat the gristle of the chicken, and you'll be fine."

EVERY YEAR ON CHRISTMAS EVE a wreath of fresh evergreen appears on Johnnie's grave. Evelyn hasn't put it there. Neither has anyone in her family. Nor have any of her friends or neighbors that she knows of. It's a bit of a mystery that Evelyn has come to expect, though the wreath's sudden and inexplicable presence always startles her.

"There it is." We pull up to the cemetery piled into Joneve's old Mercury right at sundown, Christmas Eve. There it is, a deep green wreath standing out against the winter's dead.

Joneve pops the trunk to reveal little clutches of brown paper bags. No matter how cold or what still needs to be done at home this night, Evelyn enlists a couple of her kids to help put the luminarias around the graves of ancestors. Joneve hovers her foot between the brake and gas, going real slow down the single dirt lane of the cemetery, while Vince sits on the back bumper, lighting the candles and pushing them deeper into the bags of sand so they'll burn all night long. If you're lucky, and it's not too windy nor the snow too thick, the candles will burn until morning before fading into the sand below.

Whenever we come upon one of the Losacks or the Curtises or the Salces, Evelyn scoots out of the passenger seat and walks to the edge of the grave. It's the coldest night yet of the year. I follow behind, clutching a handful of *farolitos*. They are warm in my hands.

We place one at baby Armando's, then at all the graves of the other ancestors. Over there, just along the stone wall, is old Cora Headington and her sideways grave. She wrote about how villagers back in the early 1950s would light bonfires and gather around on Christmas Eve to laugh and tell stories. The women would bake anise-spiced *bizcochitos* and crescent-shaped *empanadas* stuffed with quince or apricot or whatever had been plentiful that year. They'd wash it all down with the local sweet and earthy wine. She noticed that when electricity started coming to the area, artificially lit trees were starting to appear in villagers' homes. Cora feared they portended a time when folks would gather inside on Christmas Eve rather than outside huddled around the little bonfires. "We can only hope," she wrote, "that the old ways will endure, for when a simplicity has been lost there is always something a little alien, a little false, in its recovery."

Splayed out several feet to the north of Johnnie's grave are rocks pushed into the sand forming the word *LOSACK,* looking like the names kids spell with seashells at the beach. Evelyn's children have saved spots right next to their parents.

Evelyn's place in the cemetery is here, too, right next to Johnnie. Her name is already inscribed along with her birth year, then the dash, then a blank spot for the unwritten date that will follow. Beyond that is Evelyn's simple last inscription: "And I'll sing on…"

The sun has set over the mesa and the luminarias begin to glow. They light our way out of the cemetery toward home.

The post-holiday, mid-winter nights are now at their longest and darkest. The farm, its fields and orchards, are muted. Everything put away for the winter. The land is resting, and so is Evelyn.

Even so, a familiar incantation can be heard around the farms and gardens and about town, a refrain that months earlier, in all our harvest exhaustion, we would have denied ever thinking: Next year Next year we'll win the state fair Best Relish competition, and have the biggest and best fruit. We'll stay on top of the squash bug. We'll get all those weeds early, before they've even had a chance and definitely before they've seeded. We'll plant on time, we'll plant more in fact; we'll try new beans and definitely have more corn. And we'll make more time to can and freeze it all. *Next year*, it will all be better. Dreams begin to incubate. We start a Garden Plan.

"And look what we have now," Evelyn says as she hands us each a Ball-jar full of something so deep red and sweet-looking it could only have come from something hand grown. Jam made from some of her New Mexican wild cherry trees, started from seed tossed in a whim one day over the shoulder.

Evelyn lights a tall votive candle on the credenza and pours Jen and me some cider sparkling and lively with a few years behind it. All winter long she's been burning tall candles for friends who are sick or in need. She's already burned through two St. Jude's.

More heirloom tomatoes? Jen proposes. Hmmm, finicky, they get sick too often, like delicate, sheltered children. Besides, Evelyn loves fresh

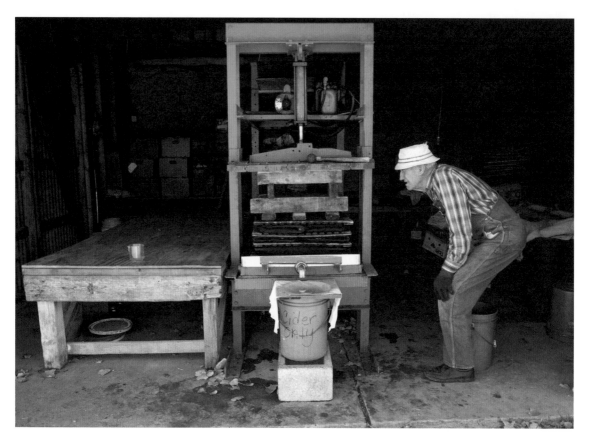

Johnnie tinkering with the cider press

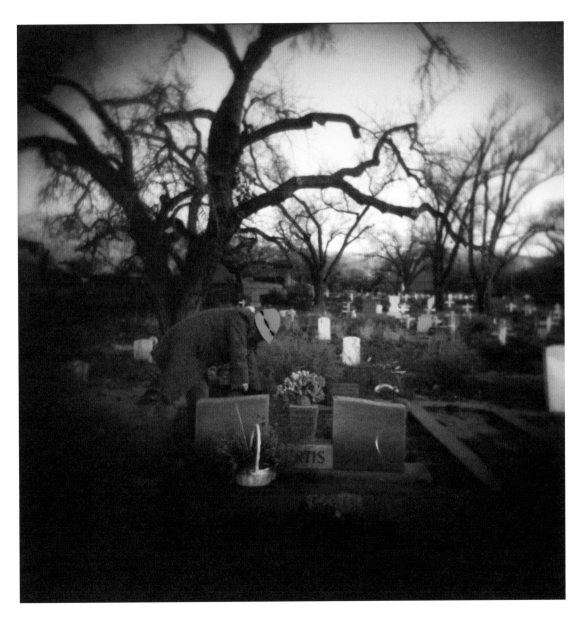

Evelyn and her ancestors, Christmas Eve, San Ysidro campo santo

tomatoes and won't share or sell them. Popcorn? For some reason, she's been hoarding and stockpiling bags of the seed in the barn. If the mice don't get it, could be a nice cash crop. Mushrooms? Evelyn nixes that idea, something about needing "a big hole," and that's just too much trouble. Winter squash? "Too many fence-jumpers. Like him," Evelyn says, motioning to the large, awkwardly colored winter squash she's had on the credenza all winter, the product of two squash that she says shouldn't have met. "Bless his heart, he just sits there."

We'll definitely grow more cucumbers. Jen's already rough-drafting pickle-jar labels we can flash under tables to customers at the growers' market, directing them down to the farm to obtain the pickled contraband.

It's a good time for just looking out the window. Let the dreams flourish now, as summer affords no such luxury. There's a comfort in knowing that everything has its time on the farm. Each season is lived and celebrated for what it is and when it is. There's no rush. We sip cool cider in a warm kitchen.

Out back, crows have gathered under the bare pecan tree. Beyond that, a weak winter light breaks through the orchard and the crows take flight. They hover over the field like a thousand scattered daydreams.

Winter is the time to watch the snow fall, and to hope for the snow to fall, for what snow is in the mountains will be the water in our fields. It's the time Evelyn starts worrying whether a late frost will hit that could devastate the orchard and leave the farm fruitless. Or whether the honey bees will possibly recover from disease to pollinate our crops. Or just how much to till the soil to bring more nutrients to the surface without losing what's already there.

It's a give-and-take connection that farmers have with the earth and with what they cultivate. They read the land and the wind like a lover. They learn to dance with it all.

People zip up and down Corrales Road past the farm, more aware of how many bars they have on their phones than of what fruit happens

to be in season or what phase the moon is in so you know when to plant potatoes. Evelyn's world—the things she looks after, the things she worries about—somehow don't factor in that much.

This farm can seem so far away.

I have liked having this dance. I have liked living as if these things mattered.

The maddening whir of chainsaws jolts the winter stillness, sending cranky, honking geese into the sky. The winter pause doesn't seem to last long around here, as January brings what Evelyn refers to as "the Great Ordeal"—pruning time. She retrieves her favorite chainsaw and pruning shears from her underwear drawer, where they're hidden so no one steals them.

This year's job is bigger since the orchard hasn't been pruned in a while due to the prohibitive expense and manpower needed. The last time it was pruned, a half-dozen volunteers from the Los Compadres Club of Corrales came out for several weekends. This year her kids and tenants are trying to prune the orchard during breaks from their jobs. Her grandson Jeffery still sports the puffy remains of a scar across his face, a souvenir from last week when he fell off the ladder onto his chainsaw. His shoulder must have somehow tripped the safety button on his way down out of the tree, averting complete disaster.

Today Jeffery navigates the ladder around golf balls left from last season by a neighbor practicing his putting. He works quickly with the others, row by row, for it all needs to happen before even the first sign of spring. They've already put in almost two months' worth of weekends among the trees and they're not even close to being done.

Jeffery shimmies up the center of the tree and fires up the saw. Even with tall ladders and climbing skills, there are parts of the tree you really can't reach to harvest. He sacrifices those limbs to strengthen the more

Fruit leather drying in the sun

Joneve checks the Winesaps

accessible ones. He cuts the unwanted suckers that only drain the tree of its energy. He cuts the low hanging branches that hit Joneve in the head when she mows in the summer. He lets go of anything dead or unlikely to survive. Down fall the dusty red limbs into the matted orchard grass underneath. Down fall the limbs deadened from the elements.

Pruning is as much art as science. You need to prune enough to encourage growth in the right way but not so much that you shock the tree. Then there's the whole question of pruning the tops. If you do, Evelyn warns, suckers and shoots will pop out at the cut and you have a new problem next year. She likes to take the approach of "if it ain't broke, don't fix it." And don't prune too heavily on the southwest sides of trees because you could get the Southwest Scald. In fact, you better have planted the tree with the strongest part facing southwest to improve its defenses against sun and wind.

I can fill notebooks with stuff like this that Evelyn's passed on. I've learned to wrap cucumbers in cloth before putting them in the refrigerator, to add vinegar to soaking beans (cuts down on flatulence), and that you really shouldn't sing in high heels even though it looks nice—something about the tummy bulging out when it should really be straight and tucked in. I've learned to be on the lookout for plant volunteers when weeding. Stumbling across an unplanned tomatillo or pumpkin amidst the bindweed is like finding a wad of money in the parking lot. You feel so damn lucky, and you didn't have to do anything for it. I won't forget to sell by volume, not weight (or is it the other way around…?), and if the peach doesn't come off the tree with a gentle twist—it's not ready yet, don't force it. Evelyn taught me that hoeing a row of chile may be harder work than using a rototill, but it's often better for the plant. And keep your damn hoe sharp, even if you don't like using the sharpener. Everyone should have one good kitchen knife to turn to, especially the ones from the Golden Corral. I've had my arms sore with work that may not pay off; in fact it may all just

end up in a complete disaster. I discovered that one bad apple does spoil the whole bunch. That it's only freezer-burn if it tastes bad. That being home is about plunging your arms up to your elbows in its soil, climbing its trees, letting your voice go in the wind. It's about not forgetting who came before you and from where you came. It is vigilance for water you won't be around to drink, for people you won't know, for a land you won't walk across but are vitally connected to saving and protecting just the same. It's using your good China. It's singing opera while making pies. It's planting trees from seed.

Jeffery finally emerges from the trees, and we call it a day. We stack up wood to cut into logs to keep us warm next winter.

At home I take a long look at the saplings I planted last autumn to replace the old ones that died. A cottonwood, a couple peaches, a plum. I'll have to figure out how to prune as they grow. I've got my notes from Evelyn, yet it seems that pruning has a lot more to do with having a gut feeling arising from a lifetime among trees. You have to know what you're going to cut and let go of, and what is worth trying to save.

I hope I'll remember what to do.

GOING HOME

MOM WAS TURNING EIGHTY-FIVE THIS YEAR. Ten years ago, she had left Indiana, left the grey, hanging skies and the house she and my dad built just after World War II with bricks her father saved from an old road. Left the purple crocuses that every year emerge as the first

flower of spring just outside the picture window. Left too many old friends and family now buried in the cemeteries south of town.

She left her home and followed me two thousand miles west to New Mexico when it seemed I wasn't going anywhere again soon. Though my mom's new anchor is now the Sandia Mountains that rise eastward from her new picture window, all her stories still start and end back in the old neighborhood. It's as if she's just borrowing this new place, just passing through. She may live here now, but her home is back there, where it all started, where it was, season after season, and always will be. Where I thought mine would always be, too.

We packed our suitcases and headed back home for her birthday.

There's nothing quite as disorienting as getting lost in your own hometown. The shock of discovering that the unquestionable landmarks that once guarded the known, secure boundaries of childhood, the things you could always find, even in the dark, that the ones that would always be there to direct you, to help you find home, have somehow been replaced, overshadowed, demolished.

We drive around downtown Indianapolis, tilting our heads against the rental car windows searching for the Indiana Bank Tower, once the tallest building around. On the Fourth of July, they'd shoot fireworks off the top of it, it was that tall, and you could see them from forever around. Now it has a different name, and you really don't notice it much anymore because new buildings have emerged, passing up the Indiana in stories and stature. We pass by a bridge no longer there.

Everywhere, on all the streets, there are people we don't know and who don't know us. We drive in circles, turning the wrong way down one-way streets. This doesn't feel like Indianapolis, Mom says. "Which way, Ma? Which way do we turn now?" I stare to the left, Mom to the right. "I don't know," she murmurs back.

We stumble onto the Slippery Noodle blues bar, and it's like spotting an old friend at a party where you don't know a soul. Going there always meant slipping into the badder part of town. Beer-sticky vinyl chairs, dark windows, swaying patrons among scattered tables, only a curtain of cigarette smoke separating the musician from the crowd. Yank Rochelle chewing out "She Caught the Katy" on his old mandolin. It was a good bad. Now, it would seem, the Slippery Noodle has become: The Slippery Noodle. There's ample, easy parking next to a new al fresco seating section. Inside: No Smoking. The lighting's been brought up to code.

I want to take my little boy through the ancient Egyptian tomb at the children's museum, the place where as a child I would lose myself among the mysterious hieroglyphics, the spooky sarcophagus and statues of Cheops and Nefertiti, the place that made me lie awake at night dreaming of adventures in far-off places. We find the museum, but the tomb is gone, replaced by interpretative touch-screen displays and a very large food court and gift shop.

We drive west and spot the HOT sign at Long's Bakery over on 16th Street. The sign is still glowing, letting everyone know that the donuts are just out of the oven. People are already lined up all the way past the coffee pots and the newspaper box. Long's are the best donuts in town—they still are—glazey, hot, sweet O's that melt in your mouth. Back in the day when my dad's parents lived down the road a ways, the family would get together and play cards all night long—poker and cribbage. At dawn Mom would trek down the street to Long's as the first batch was just coming out. Then the whole family would head to Sunday Mass.

This morning we join the line and work our way to the counter so my boy can smell the first sugar-yeast glazes of the morning. We pass my grandparents' old house, which burned down some years back. Mom thinks it's still the same sidewalk out front, one my grandfather made.

We turn onto Massachusetts Avenue and are happy to see that Stout's Shoe Store is still open, now in its fifth generation. Twice a year, while I

was growing up, we'd make our way downtown to Stout's, in spring for Easter black patents and summer sneakers; in fall for school shoes and winter boots. It was our equinox.

Opening the glass-paned shop door I'm back again. It still smells of unworn leather and heavy wooden shelves, high polish and gum balls. A black-and-white photograph of Harry Stout hangs by the front desk: Harry in his dress slacks and white shirt, tousled hair, bow tie a bit off center. Old ghosts won't leave. Everything about Harry was just a bit askew, as if he just had a sneezing attack right before coming around the corner to greet you, but always with that smile. Like you were in on a joke with him that no one else knew. We used to play this ongoing game of tag for years. Somehow Harry would always remember from the last visit who was It. No matter how many customers he was dashing between that Saturday morning, he'd flash his smile and tag me on the shoulder, "You're It!" and disappear around a shelf of shoes.

Over there in the corner was where the little old shoe lady used to sit, quietly working away at an anvil on her repairs, old tools from an old trade, tapping away on heels. She didn't talk much, but she could fix anything. You could come to her with any problem in the world, and she'd reach down, find the right tool, and hammer it out until it was all back to new.

The best part about coming to Stout's was when you actually bought a pair of shoes. The sales clerk would carefully wrap each shoe in tissue paper, place them in a wire metal basket, press a button, and away they'd soar high into the air whisking across the store to a mezzanine where a man would wrap the shoe box in brown paper, set a perfect crease, and send your box zipping back in the basket, high above all the shoppers below, to the cashier, who would hand you your box of new shoes. This is what I knew of buying shoes as a child.

A man appears from around the corner. It's Harry, the same hair, the same trousers, and I want to run up and tag him It, but then I see he's younger than the Harry I remember, without the bow tie, and he says,

"May I help you," without that smile, and I know then it's not Harry but Harry Jr.

We buy shoes we don't really need and take our wrapped boxes under our arms, and Mom calls back to Harry Stout Jr., "I sure hope you're here forever." His response stays with me. "Nothing lasts forever, ma'am, but we'll sure try."

We make our way down to the south part of town to the cemetery. The cemetery caretaker has just mowed around each grave. My boy runs back and forth, dancing around tombstones of ancestors he's never met.

I'm not sure how or even why I thought I could go back. Someone else, after all, is living in our house. They've torn down the old garage. The sycamore out front isn't home base anymore. Someone else watches the fireflies light up the muggy green summer trees from my old bedroom window upstairs, and dreams. "This is momma's old home," I tell my little boy as we turn down Ralston Drive. He asks why we don't go in then, and I'm surprised, too, that we can't go in. I should be able to just pull up in my driveway and throw my arms around it, like an old love. Instead, we can only just drive by. Real slow, staring in. Until someone is staring out back at us through our old picture window. We look away then, aware of who we are now, and drive on.

We meet up with old friends to celebrate Mom's birthday. The conversation picks up seamlessly where it left off years ago, as it will with people you've known way back. And then there's not much more to talk about. You visit them like you visit a favorite old place. After sitting for a while, it's time. You are no longer part of each other's daily geography.

We drive past Nana's old house two blocks over. There, on her front porch, we would visit in the late afternoon and into the early evening, the back and forth of our porch gliders our only job, bright pink strawberry ice cream melting down cones into our hands. The world could go on by.

How does Evelyn feel when she passes house after house of people she doesn't know in her village? When she walks across the blackberry patch where she first fell in love, the vines now graveled over? The mesa that stretched farther west than she could ride a horse in a day now has an end. All her aunts and uncles are gone. Her parents, her husband. Her fellow villagers can drive by not even realizing farmers still exist. Fields measured off into one-acre housing developments. Orchards planted and maintained by hand for years, season after season, now forgotten, apples left for the birds.

And yet she moves about this place, connected to something I cannot see.

My mom and I stay for a couple more days in a downtown hotel, high above the city, where I look out of a window that won't open onto a place that has become not my home anymore. I am unvital in the goings-on of this place. I left a long time ago.

A FIELD ON THE EDGE
OF WINTER

IT'S BEEN A LONG TIME SINCE AUTUMN, when the water flowed from the river through the village. The acequias are quieted now with grounded tumbleweeds and the footprints of thirsty coyotes. The air is filled with the silence of cranes picking through the blanched fields of late winter. Life is going on elsewhere.

Up ahead of me the cranes are moving through the remains of the field. They're searching for food before making their journey back home. By the week's end, they'll be gone. A season is ending and nothing there yet to take its place.

Just then, they take flight. At first, just two or three. Then a group forms, and soon the whole flock is angling up into the sky Ash Wednesday grey. For a moment, I can't tell if the flock is flying toward me or away. It must be how the late winter's light slants and falls off. It circles up, higher and higher, farther and farther, like the way a morning dream is so vivid upon awakening, and then fades, until somehow it can't be remembered.

I look up, and just like that, it is gone. And I'm left standing in the field alone.

Pruning time

Fruit leather tables at the end of the day

SPRING

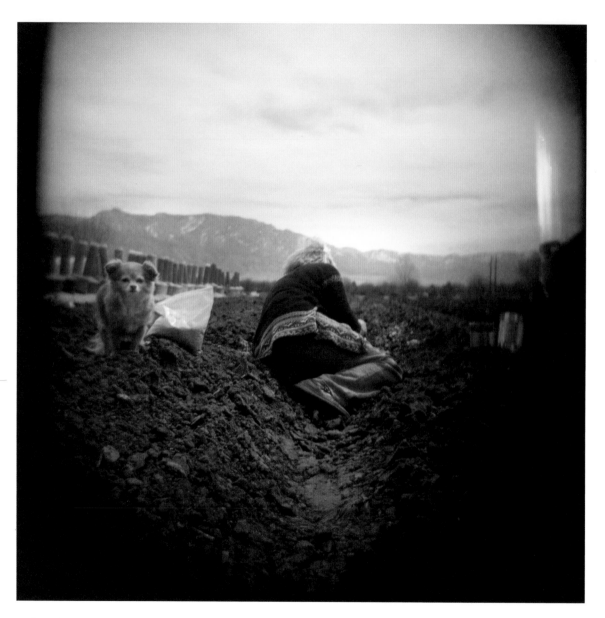

Evelyn in her rows with Goldie

SPRING, AGAIN

"Keep the faith with all this, honey."

I WATCH EVELYN OUT THERE AMONG HER ROWS, burying seeds in this land as if it will be this way forever. Furrow. Row. Furrow. Row. Furrow. Row. Her land and life have been measured out.

"Nothing lasts forever, but we'll sure try," Harry Stout Jr. called out to us from his little shoe store.

The acequias are filling now with spring runoff. Dusk comes a little later, lingers longer. In the field on the way to Evelyn's farm, alfalfa springs back to life. The cranes and geese have left behind small feathers that are now pale yellow butterflies alighting through the green. They flicker and wink so that when you pass the field it seems alive. By night, they arise and become stars.

Evelyn's old '49 Farmall tractor, the one she grew up on, the one she still occasionally climbs atop with a little boost for a parade or a picture, is making its way up and down Corrales Road, just as it has for over half a century, being loaned out to those who need a field plowed.

Everywhere you go in the village people ask, "So, what are you planting this year?" Not *are* you planting this year but *what*. Evelyn calls farmers a bunch of "benevolent jackasses." They mean well, but dammit, they're stupid and foolish for doing all this work. People who a few months ago swore they wouldn't plant again are doing just that. Even Tony is out there on his hands and knees fitting little fingerling potatoes into furrows that Vince is digging. Ysidro over off Old Church Road, with his expanding resumé of health problems, swore last year when I passed by: "No more." I hear he's told a neighbor this year "only three rows," unless of course the neighbor wants to help out a little, and then "well, we can plant five or six rows, *porqué no?*"

I get a call. It's Benevolent Jackass Evelyn.

"Honey, what do you know about this stevia thing?" While putting her feet up earlier, she got to reading some article about a professor or someone-or-other advocating that we all plant stevia. Apparently it likes the tropics, but for some reason Evelyn can't recall the professor thinks we can grow it here.

I go over and we find a bottle of it, unopened, behind the Jell-O boxes in her cupboard. We taste it. Huh. I put it back behind the Jell-O.

"Well, honey, we have to try and grow something no one else is. Where do you suppose we can get the starts? And why didn't we plant fennel last year? Or did we?"

It is spring, again.

All winter long Evelyn has been telling people she is too old to farm anymore, that she can't keep up with it all. We all listened, slowly nodding our heads. At one point, she landed in the hospital for a few days. Her kidneys again. The room soon became filled with flowers from state senators and cookies from neighbors, crock-pots of chile and issues of the *Potato Farmer* mixed with cards and bills. The Mormon kids stopped by to sing her some songs. St. Nicholas stopped in to get Evelyn's suggestions for the village Christmas party. One night Joneve came to visit

wearing her big, puffy growers' market coat concealing a stash of candy bars and chubby little Goldie. All the nurses got jam.

Evelyn is determined to find stevia. She grabs her cane but skips the purse, which just gets in her way. "The police can follow me the hell home if they wanna see my license, and I'll be glad to show it to them."

Eventually we find some willowy starts; we're so excited we just buy them, not exactly sure how we are supposed to get liquid out of the leaves. I'm imagining a lot of wringing; Evelyn's thinking the blender.

Earlier this week, several farmers and growers from the village and the valley gathered for a group picture for the newspaper in front of Casa Vieja, our prized restaurant that buys and cooks local produce. Old corn-beans-squash-and-chile farmers who always know just how much water is in their ditch stand next to the young and the landless who bring to market rediscovered heirlooms, blue Peruvians, kale, and gluten-free tarts filled with homemade chevre grown with drip-irrigation on borrowed land. They're joined by people with day jobs and fruit trees, and kids with turquoise chicken eggs.

There's Evelyn, in the center of the picture, smiling. Everyone's chatting with everyone else. What are you putting in this year? Chile's going to be hot, you can already tell. Hope the freeze doesn't hit the apple blossoms. Wonder if we'll have enough irrigation water to make it through October.

Evelyn leans over to me. "Honey, this gives me hope."

Everyone stops talking, just for a moment, and the image is made.

Signs are this will be a good year for growing around here. Several local teenagers have been hired to farm the Gonzales field that the village saved from development. The "pantry garden" my neighbor Penny Davis and her husband Sandy started as a little something to do in their retirement is now a full-fledged farming venture, with

dozens of volunteers to help her grow and harvest vegetables measured in the ton on land that villagers are letting them use. Each week they deliver fresh produce to several food pantries and to needy folks very grateful to have food from something other than a box or can. Even wine making is making a comeback in Corrales. Lines of vines zigzag the village. Weekend growers donate their grapes to help supplement those grown at our wineries.

For someone who wasn't going to plant this spring, Evelyn sure has a lot of seeds already in the ground and more on their way. Besides the stevia there are some four hundred feet of onions, row after row of beets, okra ("for the Southerners"), mung beans (there was a sale), chile, dill and chamomile and basil and oregano, pumpkins, several varieties of cucumbers, melons, yellow squash, crookneck squash, green squash, green beans and purple beans, carrots and celery, potatoes from the pantry, and tomatoes from the dumpster-dived heirlooms Evelyn stashed away to dry in the garden last summer. A moment of panic had ensued earlier when Evelyn went trolling the barn for seeds and discovered that field mice had eaten the entire cache of Uncle Gilio's prized blue corn. It seemed like the end of the line until she found a couple dried ears stashed in an apple crate and salvaged a few more ears from a centerpiece she had made back in the fall.

Evelyn and I have a tenth of a field planted by the time I leave to pick up my boy from school. Inside, Mr. Frank's class is practicing on the steel drums. A calypso version of "Somewhere Over the Rainbow" drifts out into the parking lot, into Mrs. Losack's impossible potato field, across the way and into that long-ago blackberry patch where Johnnie met Evelyn.

If things should change, and they will, our son will still always know this piece of land as his first schoolroom. He'll know this little village as the place where he learned to climb trees in old cottonwoods along riverbanks and ride a horse without a saddle. He'll know what summer

is supposed to feel like, that the smell of fresh apples and roasting chile means autumn. That Halloween is bumping along ditch banks on a hay wagon attached to your dad's pickup with nothing but moonlight, your friends' laughter, and La Llorona floating by. He will never find another place in the world that has posole quite like TC's down at the Tijuana. He'll mark the passage of time by the changing colors in the bosque, from amethyst to green to yellow to auburn. Here is where his story will start, and here will be his home.

There's an old Spanish phrase for the feeling you can have about a place—*la querencia*. It's about having a connection to a place that cannot be severed. It's the way you feel about a place that is your homeland, the place you love, the place your soul craves. It may not be the place where you were born, but it is the place where you belong.

It's the last night of April, and I am very tired. Spring is hard work. The weatherman is predicting a hard freeze for the night, with temperatures possibly slipping their icy way down into the 20s. It's only dusk but already getting cold, and I consider the possibility of just going to bed.

Then the phone rings. It's Evelyn.

"Honey, we're trying to save the trees. Everyone's out there watering. We might just save them!"

Tending to a fruit orchard requires the vigilance of parents of the very young. For years, Vincent and Dulcelina rose in the night to light smudge pots throughout the orchard to warm the delicate blossoms. At one point, Vincent even attached old World War II airplane propellers to the top of the barn and connected motors so they'd keep the air moving to ward off the cold.

This evening Evelyn's family, after working all day in their various town jobs and skipping dinner, heads back to the farm to mobilize. Evelyn is determined to use fellow old-time farmer Gus Wagner's technique of

flood-irrigating the land affecting an alchemy of nature and physics where heat that is released from the water underneath warms and protects the trees' buds and flowers.

There is memory among these trees of killing frosts. For years, Evelyn's parents cared for hundreds of peach trees they had planted between the apples of their orchard. People came from all over to buy them. Then in 1971 a big frost hit on May 15, San Ysidro Day. It got so cold that night that Dulce could hear the bark on the trees cracking and popping as the sap inside expanded and contracted. All the peach trees died, and hundreds more apple trees were severely weakened and eventually died. Vincent Curtis said it best: You work eighteen years nurturing these trees to get them to where they can finally produce some fruit, and in just one night Jack Frost picks the crop.

And so it seems that late-season frosts can be added to the difficulties that plague the farmer's mortal coil: epic floods and lack of water, global warming and blight. Apples from Australia. Progress. Bindweed. Bad luck, bad seed, bad backs, and the lack of a good, dependable, properly sharpened hoe. Earth, water, air, fire. Wind, frost, mustard weed, squash bugs.

From 2,500 fruit trees at the farm's height perhaps 200 remain.

It is all so much work. So much work. Why do we bother doing what we do? What's the point, when so much is out of our hands? Why do Evelyn and her son roll out of bed at three in the morning to bake pies for market, or why does her daughter hunker down in the frigid cold at the winter markets trying to sell a few quarts of cider? Why do we hoe rows all day when the wilt is coming, or climb into trees to retrieve apples that might get passed over? Why is everyone working so hard to keep this little farm going?

Dulcelina Salce Curtis believed in this farm. And, along with these trees and this land and her caramel apple recipe, she passed that on to Evelyn.

This farm asks only that we believe in it, and it, in turn, gives us a place to believe in.

To be that needed by a place. To need a place that much. This is home.

There's an amazing thing about apple trees, Evelyn will tell you. There's something called cambium just underneath the bark. Evelyn calls it the lifeline. The tree can appear dead from fire, drought, hard freeze, long life. Fallen branches, no leaves, scorched bark, no fruit. Yet the potential for life is still within. Dotted here and there today in the orchard are trees just like that where little shoots have sprung from surviving pockets of cambium. The tree, despite it all, will live on.

Night begins to fall, the temperature begins to fall, and we all go to sleep. What will happen now will happen. We'll hope for the blossoming fruit to hold out against the cold.

And then, when she wakes up in the morning, Evelyn will go outside, among her trees, among her place in this world, and see if all this going-to-the-trouble is going to matter, and whether something will be saved, in the end, after all.

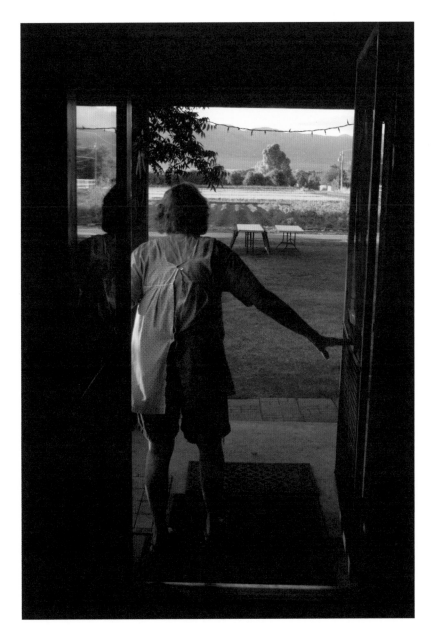

End of day, farmhouse

ACKNOWLEDGMENTS

MANY THANKS GO OUT TO MY FAMILY and friends, who have given generously their encouragement, support, advice, and patience throughout this project. A special thank you to the staff at the Museum of New Mexico Press for believing in this book and bringing it to the community: Anna Gallegos, David Skolkin, Renee Tambeau, Jason Valdez for his design, and especially to my editor Mary Wachs for her wisdom and heart, for getting it and making it all come together.

I would especially like to toast the following:

To all my instructors at Ritter High School, St. Mary-of-the-Woods College, and the University of Missouri for instilling in me compassion, ethics, and how to tell a story. The *Albuquerque Tribune*, for helping me find and form my path. Jen Northup, partner in crime, thank you for picking all that okra. We'll sweep the state fair pickle category yet. Ollie Reed for cold beers, your front porch, writing advice, and not laughing at me when I sing (rolling, rolling, rolling, though the streams are swollen…). Joneve Bender for sort of looking the other way when we got to planting more. Vince Losack for all those furrows and rows, rows and furrows. Scott Momaday for the wine, the chocolate, your poetry, your laugh, and key advice to write to the project, for the project. Jack Loeffler for teaching me that slices of sound are just as beautiful and palpable as the still image. To the street people of Las Paredes,

for all the well-timed happy hours. Annie Bromberg for helping me learn to hear all those moody and drifty muses and knowing when to just go and soak instead. Mary Davis for her passion and commitment to Corrales, for her historical guidance, for indulging me and pulling out all the old maps and photos. You are a jewel to this community. John Brown for his advice in understanding New Mexico's water situation. The Village of Corrales's Historic Preservation Committee for its commitment to our history. And to all the Corrales residents who have helped tell Corrales's story, including Ruth Armstrong, Gloria Zamora, Cora Headington, Barbara Williams, Jim Findley, and Pauline Eisenstadt. Jeff Radford for his tireless devotion at the *Comment* and his coverage of Corrales's agriculture. Dan D'Allaird for his invaluable guidance and support in the editing stages. Scott Lewis for reminding me to keep the tangly vines off my path and just tell the damn story in my own way. Dennis Plummer for helping to keep the water flowing and gathering all those folks to my grandma's front porch. Annette Luciani for her healing chestnuts, helping to get the evil eye out, for my Corsican home away from home. Ingrid Young for reminding me to stand bravely atop those hills, for the great knitted shrug that helped me write the final chapters, and for the rum balls. They helped edit the book. For the eyes and intuitive photographic guidance of Jerry Braude, Kathryn Cook, Mary Hobbs, Steven St. John, and Mark Holm. Out, out, out, IN! For writing insights from Lisa Nipp, Mel Antonen, and Lisa Brown (long live Toad Road Farms. I miss our potatoes). Marilyn Braude for her pie crust recipe and undying encouragement. I know you are reading the book starting from the end to the beginning, so I hope you enjoy it. For Mom, for always pulling over to the side of the road to listen, for your constant love and encouragement, for all our adventures in New Mexico. For August, for being able to see the man in the moon, for loving to play hooky as much as I do, for encouraging me to just finish the book momma, so we can play. To Darren, for

always believing in these crazy endeavors, for your constant love, for getting it, for clearing the decks so it all could happen. This would not have happened without you, and I promise not to do it again. To all the spirits who've been poking around here, keeping me company, guiding me: Lori, Bo Peep, Nana, Dad, my grandparents, Uncle Chuck, Eddie Adams, Jimmy Gutierrez, John Ellison (whoever you are).

And to all the ancestors who created the path. To our farmers past and present, here and there, for sustaining our bodies and spirits. To Corrales, my home.

And finally, to Evelyn Curtis Losack, for always going to the trouble. Para Corrales. Para Corraleños.

Historical photographs are courtesy Evelyn Curtis Losack.
Project editor: Mary Wachs
Art director: David Skolkin
Design: Jason Valdez
Design associate: John Cole
Manufactured in China

10 9 8 7 6 5 4 3 2 1

Library of Congress Cataloging-in-Publication Data available from the publisher upon request.

Museum of New Mexico Press
PO Box 2087
Santa Fe, New Mexico 87504
www.mnmpress.org